# BRIDGING EAST AND WEST

## JAPANESE CERAMICS

## FROM THE KŌZAN STUDIO

Selections from the Perry Foundation

# BRIDGING EAST AND WEST

## JAPANESE CERAMICS

## FROM THE KŌZAN STUDIO

Selections from the Perry Foundation

Kathleen Emerson-Dell

The Walters Art Gallery
December 3, 1994 – April 9, 1995

Ashmolean Museum, Oxford
May 3 – July 2, 1995

THE WALTERS ART GALLERY, BALTIMORE

Distributed by
THE UNIVERSITY OF WASHINGTON PRESS, SEATTLE & LONDON

Published on the occasion of *Bridging East and West: Japanese Ceramics from the Kōzan Studio*, an exhibition organized by the Walters Art Gallery, Baltimore. Funding for the exhibition and catalogue has been provided by the Perry Foundation.

The Walters Art Gallery, Baltimore
December 3, 1994–April 9, 1995

Ashmolean Museum, Oxford
May 3–July 2, 1995

Published by
The Walters Art Gallery
600 North Charles Street
Baltimore, Maryland 21201

Distributed by
University of Washington Press
P.O. Box 50096
Seattle, Washington 98145-5096

Designed by Sherry McAllister
SDY&M, Inc., Baltimore

Photograph credits
Susan Tobin: figs. 6, 7, 9, 10, 12; nos. 12, 14 15, 23, 32, 35, 38, 39, 40
Patrick Lears: marks and box inscriptions
All other color plates courtesy of the Perry Foundation

Library of Congress Catalog Card Number: 94-61695
ISBN 0-911886-39-7

Cover
VASE WITH PEONIES
*Porcelain with* moriage *white peonies;*
*underglaze cobalt blue, mauve, green; overglaze yellow*
*H. 49.2 x D. 29 cm*
*Mark:* Makuzu-gama Kōzan sei
Cat. no. 9

# Contents

# DIRECTOR'S FOREWORD

IN ST. LOUIS IN 1904 HENRY WALTERS MADE
one of his many great purchases—a vase from the studio of
the Japanese potter Miyagawa Kōzan, decorated with the
branch of a flowering plum tree, along with a poem. The
vase—on display at the Walters since the opening of
Hackerman House in 1991—is now very much a part of our
lives, just as the plum tree depicted on the vase was a part of
the life of the writer of the poem a thousand years ago. It
seems that after the death of an ancient plum tree in his gar-
den, the emperor requested that another tree be moved from
the home of the daughter of a famous poet. She in turn wrote
that she had no choice but to obey the emperor's wishes, but
what would she tell the nightingales that had made a home in
the tree's branches?

Hiram W. Woodward, Jr., Curator of Asian Art, has sev-
eral times over the years made a case for presenting a Kōzan
exhibition at the Walters, starting with the seven pieces in our
collection and borrowing others that would reveal the range
and development of the studio's wares from the late nineteenth
century onwards. That proposal was no more than an idea
when, through an intermediary, the Walters was approached
about exhibiting the Kōzan wares that are entrusted to the
Perry Foundation. This was an offer that could not be passed
up, especially because of the presence here of Kathleen
Emerson-Dell, Curatorial Assistant for Asian Art. She was
precisely the right person to build upon knowledge acquired
from the study of the Walters collection of Meiji-period
Japanese art, uncover new facts, and present an account of the
history and development of the Kōzan studio. Ms. Emerson-
Dell selected the objects and oversaw the exhibition from start
to finish. Much remains to be learned about the development
of the studio, which spanned several decades and at least two
generations, but the reader will find in the following pages the
first thorough presentation anywhere of the story of
Miyagawa Kōzan.

The Walters, along with the Ashmolean Museum in
Oxford, is therefore proud to present this exhibition, the first
outside Japan to feature the ceramics of the Kōzan studio. We
salute the perspicacity, judgment, and generosity of the collec-
tors, and we are grateful to the Perry Foundation for its sup-
port of the catalogue and of the research that led up to it.

GARY VIKAN
*Director*
The Walters Art Gallery

# ACKNOWLEDGMENTS

MY INTRODUCTION TO MIYAGAWA KŌZAN came during my first week at the Walters in 1989, when I had to edit a Kōzan exhibition label. It was then that I learned how little information was readily available about Kōzan, in English or Japanese. I therefore welcomed the chance to research Kōzan further in preparation for this catalogue and exhibition of Kōzan ceramics selected from the Perry Foundation collection.

Two recent exhibitions of Kōzan's works in Japan (1986, 1989) laid the foundation for my research. I am indebted to the pioneering scholarship of both Hida Toyojiro of the National Museum of Modern Art, Tokyo, and Yokota Yōichi of the Kanagawa Prefectural Museum, Yokohama. I am grateful to the many scholars and friends in Japan, England, and the United States who helped me build upon this foundation. It was my great fortune to meet Clare Pollard, a doctoral student at Oxford University, who was in Japan gathering materials for her dissertation on Kōzan. She generously shared sources and information with me and was my primary sounding board for many months. Special thanks are due to Dr. Richard Wilson for locating Kōzan's biography in the Morse archives. Dr. Wilson also provided valuable insights on the Kenzan tradition and answered many technical questions related to pottery making. In Japan, it was my pleasure to discuss Kōzan over many bowls of tea with the potters Itaka Kizan II, son of a Kōzan disciple, and Miyagawa Kōsai, head of the Makuzu studio in Kyoto. Beth Garnier, who is writing a master's thesis focusing on Kōzan's glaze innovations, found the fascinating *Harper's Weekly* article. Victoria Weston, Christine Guth, Ellen Conant, Paul Berry, Naito Masato, Nakanodō Kazunobu, and Sato Doshin offered helpful insights. Kurihara Naohiro, Louis Lawrence, and Nick Shaw generously shared comparative material. I owe a special debt of thanks to Michael Goedhuis for his help during the initial stage of my research. In addition, I am thankful to Tsuji Masako, Nakaoka Yuri, Hirayama Mikiko, Okabe Masayuki, and Martha McClintock for their help in facilitating my research in Japan.

I am extremely grateful to colleagues in museums here and in Japan who graciously permitted me to study related materials in their collections. Arakawa Masaaki of the Idemitsu Museum in Tokyo allowed me to spend hours going through the sketches of Itaya Hazan. Ohkuma Toshiyuki of the Museum of the Imperial Collections in Tokyo opened cases and boxes after hours. Anne Nishimura Morse of the Museum of Fine Arts, Boston, let me photograph early Kōzans in the Morse collection. And I am especially thankful to Louise Allison Cort of the Freer Gallery of Art in Washington, D.C. for access to the Freer Study Collection and for many useful conversations.

I am indebted to my many talented colleagues at the Walters Art Gallery and elsewhere who contributed to the catalogue and exhibition. Associate Director William R. Johnston made it possible for me to take two research trips to Japan. Senior Conservator Donna K. Strahan helped identify materials and oversaw preparation of the objects for exhibition. Katie Franetovich, Jennifer Cowan, Barbara Fagley, and Mike McKee of the Registrar's Department helped coordinate shipping, packing, photography, and installation of the objects. John Klink designed the exhibition. Theresa Segreti and Julia Evins provided graphic designs. Photographers Susan Tobin and Patrick Lears supplemented the photographs provided by the Perry Foundation. Susan Wallace carefully edited and proofread the catalogue manuscript and texts for the exhibition. Elise Calvi (who also edited) and Betsy Fishman of the Walters Library and Reiko Yoshimura of the Sackler library helped locate research materials. Stephen W. Fisher, a Kōzan enthusiast, generously lent a hand wherever needed. And my husband John Dell supported my endeavor in many ways. Errors that remain are my responsibility.

I owe a special debt of gratitude to Dr. Hiram W. Woodward, Jr., Curator of Asian Art at the Walters, for his help and encouragement, and Dr. Oliver Impey, Senior Assistant Keeper at the Ashmolean, for his enthusiastic support. Above all, I would like to thank the Perry Foundation for providing us with a wonderful collection and the financial support that made it possible to present it to a larger audience.

*Fig. 1.*

*Etching of Makuzu Kōzan pottery compound, ca. 1890. After Yokohama shokaisha shoten no zu (Pictures of Yokohama companies and trading establishments).*

On May 29, 1945, Allied bombing leveled the section of Yokohama where the Makuzu pottery compound of Miyagawa Kōzan (1842–1916) had stood since 1871. The kilns, workshops, and showroom (fig. 1), established early in the Meiji period (1868–1912), were completely destroyed. The entrepreneurial spirit that had characterized Kōzan's business from the beginning was an outgrowth of policies to move Japan from an isolated feudal state to a modern nation. Japan's efforts to bridge the gap between Japan and the West—to learn new technologies from the West, to promote understanding of Japanese culture abroad, and to become economically viable on an international level—are all evident in Kōzan's work. Fortunately, hundreds of Makuzu ceramics survived the bombing. They were in Japanese *tokonoma* (display alcoves), on mantels in English parlors, in the display cases of western museums, in the homes of royalty, and on the shelves of dealers. Unfortunately, many of the primary sources that would help to tell the story of these ceramics were lost in 1945—the diaries and letters, the sketchbooks and glaze recipes, the account books and orders. What does remain, besides the objects themselves, is a partial biography, a few letters and paintings, sketches by other potters (figs. 2 and 3), some contemporary newspaper and journal references, incomplete and often ambiguous exhibition lists, some photographs in exhibition catalogues, inscriptions on storage boxes, and a few reminiscences. Nevertheless, from these sources we can reconstruct much of the history of Makuzu ceramics and understand something about the man who started it all—Miyagawa Kōzan.

Kōzan's story is one of great fame and seemingly continuous success: "one of the giant ceramic workers of the world" (1878);[1] "without a doubt the cleverest and most talented potter now living" (1897);[2] "the greatest living ceramic artist we have today in Japan" (1910).[3] We have just a glimpse of his personality from a few first-hand accounts. Elizabeth Scidmore visited Kōzan at his kiln in Nishi-Ota, Yokohama, in 1897 while she was working on an article about Japanese porcelain artists for *Harper's Weekly* (figs. 4 and 5). She enthusiastically dubbed him the "wizard of Ota" for his magical ability with clays and glazes and described him as a "suave and engaging old soul" with a shrewd twinkle in his eye and a head as bald as that of a Buddhist priest. He was susceptible to flattery but too shy to have his picture taken.[4] Kōzan's monkish appearance also made an impression on the young Arishima Ikuma, whose father was head of the tax office in Yokohama and a friend of Kōzan's. He remembered Kōzan as a stern but generous man with eyes as bright as his shiny bald head.[5] According to one of Kōzan's disciples, the workshop atmosphere was very disciplined. Itaka Kizan recalled that the master's nicknames were "Morin" and "Jan-jan," affectionate slang terms

for policeman. Kōzan is also remembered for treating his studio workers well. On one occasion, he bought Kizan a fashionable frock coat and a high-collared shirt.[6]

## Miyagawa Kōzan

Miyagawa Kōzan's ceramic ancestry can be traced back to the beginning of the seventeenth century, when Yūkansai moved from Miyagawa-mura (a village within the Shimogamo area of Kyoto) to the courtyard of Kyoto's Chion-in temple, where he made low-fired raku pottery.[7] For many generations Yūkansai and his successors were known in Kyoto as *chawanya*, teabowl makers. Kōzan's father Chōzō, the tenth-generation *chawanya*, was invited to Edo to teach raku pottery-making under the patronage of the feudal lords Shimazu and Date.[8] When Chōzō returned to Kyoto, he studied for five years with Aoki Mokubei (1767–1833), a literati painter and potter who was known for his imitations of Chinese Ming-dynasty porcelain styles. According to Kōzan's biography, his father had wanted to return to Edo after Mokubei died, but responsibilities in the family business kept him in Kyoto. He expanded the range of wares made at the family kiln, producing not only high-fired porcelain utensils for *sencha* (steeped tea), but also stonewares for *chanoyu*, the Japanese tea ceremony, in the style of Nonomura Ninsei (act. ca. 1647–1677). In 1851 Chōzō opened a kiln in the Makuzugahara section of Kyoto to produce, among other wares, *sencha* utensils for the imperial court. Members of the imperial family bestowed upon Chōzō two names that his son would take to Yokohama and make known around the world. "Makuzu-yaki" (Makuzu ware) was the official name given to Chōzō's wares by Prince Yasui-no-miya, and "Kōzan" (incense mountain) was the art name given to him by Prince Kachō-no-miya.[9]

In 1860, at the age of eighteen, Kōzan inherited his father's art name and the responsibilities for running the Makuzu kiln. His father died in March of that year after a four-year illness, and his elder brother Chōhei, described as being sickly, died three months later. In actuality, Kōzan had probably been running the workshop since he was fifteen. Prior to this time of adult responsibilities, he seems to have been a precocious and clever child.[10] At the age of nine, Kōzan was asked by his painting teacher Chokian Giryō[11] to make a brushwasher. Knowing the water in the washer would become dark with ink, Kōzan placed the figure of a dragon on the bottom. It was a three-dimensional play on the popular painting theme of a dragon rising through misty clouds. The wit and the interest in sculpted attachments were qualities that remained with Kōzan throughout his career.

Little is known of the ten-year period during which Kōzan

ran the kiln in Kyoto. Presumably, he continued in his father's footsteps, making porcelain and stoneware tea utensils for *sencha* and *chanoyu*. In 1866 the shogunal government commissioned him to make a large set of *sencha* tea vessels, described as *sometsuke kinrande* (underglaze blue with red and gold) as a gift for the emperor.[12] From 1868 to 1869 he was invited to make tea wares at Mushiage kiln in Bizen province.[13] This was the private garden kiln of Iki Sanensai, a tea enthusiast who was the chief retainer for the Ikeda daimyo. Since its founding in the 1830s, Sanensai had invited other well-known Kyoto potters to work there, such as Ninami Dōhachi (1783–1855) and Seifū Yohei I (1803–61).

No sooner had Kōzan returned to Kyoto in early 1870 than he made the decision that would start him down the path to fame—the decision to move to Yokohama. Such a move could not be made without prior connections. Kōzan's acquaintance with Komatsu Taitō, an official of Satsuma province and a friend of Iki Sanensai, brought him to the attention of a Satsuma merchant living in Edo whose name was Umeda Hannosuke. Umeda and his brother-in-law Suzuki Yasubei, a successful export trader, wanted to invest in a kiln that would produce Satsuma-style wares in the new export city of Yokohama. There was a great demand for these kinds of wares in the West, but they were being produced in places that were inconvenient for shipping, thus adding to the cost. As a way of cutting expenses, some merchants were already importing white stoneware blanks from Satsuma or Kyoto to be decorated with colorful overglaze enamel designs in Tokyo or Yokohama.[14] Umeda offered to build Kōzan a kiln and workshop on Suzuki's land in the Nishi-Ota neighborhood of Yokohama. Suzuki would manage the business and be the sole agent. Kōzan left Kyoto with his wife, his son Hanzan, and four assistants. He told his associates that he was moving to Yokohama "to make export ceramics to increase the wealth of the country and to become famous here and abroad."[15] He achieved both these goals within the first eight years in Yokohama.

During this period he won awards for his ceramics at various international and national exhibitions—a gold medal at the 1873 Vienna International Exposition, a bronze medal at the 1876 Philadelphia Centennial Exposition, an Imperial award at the First National Industrial Exposition in 1877, and another gold medal at the 1878 Paris Exposition Universelle. The large international expositions were especially important venues for Japan to advertise its products and promote trade. Suzuki Yasubei's exhibit of Makuzu wares at Philadelphia included typical export items: flower pots, coffee sets, lamp vases, covered bowls, tea jars, censers, and ornamental pieces. A covered jar in the Walters collection (fig. 6), identified as a Kōzan piece by Henry Walters' pencilled notation on the

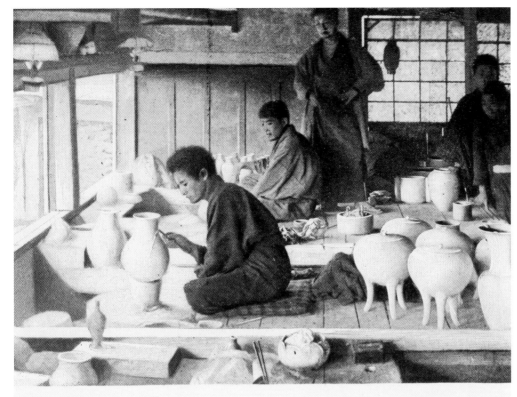

IN MAKUDSU'S WORK-ROOMS—APPLYING RELIEF DECORATION ON THE BISCUIT.

*Fig. 4.*
*Kōzan's workshop.*
*Photograph taken*
*during Elizabeth*
*Scidmore's visit in*
*1897. Harper's*
*Weekly 2144*
*(January 22, 1898).*

underside of the lid, is most likely an example of the popular Satsuma-style wares marketed by Suzuki.[16] However, Kōzan is also listed in the official catalogue as a separate exhibitor, and one suspects he won his award for something a little different. In 1876 and 1878 Kōzan attracted notice for exhibiting innovative wares, mostly stoneware but also some porcelains, with high-relief attachments such as lotus flowers, bamboo, hawks, crustacea, sparrows, fish, and sages.[17] The small porcelain ewer with sculpted bamboo culms and leaves, animated by painted sparrows and a little attached snail (no. 6), must have been made at this time. Contemporary critics were quite taken with them, calling them "remarkable works of a different style," "notable examples of skilful potting,"[18] and "so wonderful that they appear to be *tours de force* rather than works produced for the ordinary purposes of trade."[19] These early innovations, so wondrous at the time, would be reassessed some twenty years later by revisionist critics, most notably Captain Brinkley, as "monstrosities never tolerated by Japanese connoisseurs and soon rejected by foreign buyers" and "the worst aberration of Japanese keramic [sic] conception."[20] Far from being disgraceful aberrations, they reflected a time of change and openness in Japan, when Kōzan was able to stretch his artistic mind and extend the boundaries of old traditions by combining sculpture and painting with ceramics. Contrary to Western notions of Japanese taste, Kōzan's countrymen acknowledged him for his works in this new style. At the First National Industrial Exposition in Tokyo in 1877, not only did he win an Imperial award for one of his vases, but the Emperor himself drew attention to it by actually touching it. The vase is described in Kōzan's biography as a jar made from

rough clay decorated with a gourd vine that was made from a different colored clay and was in such high relief as to appear detached from the body of the vessel.[21] It was later purchased for the imperial collection.

After the Philadelphia exposition, Kōzan's relationship with Suzuki Yasubei came to an end, allowing Kōzan more freedom to run his own business and explore new types of production. He established a brief connection with the export company Kiritsu Kōshō Kaisha at this time,[22] producing some commissioned works for their exhibit at the 1877 First National Industrial Exposition. He also received money from this company to develop methods for applying cloisonné enamels to ceramics. Although he did not pursue this line of production after 1881,[23] his experiments most probably brought him into contact with imported Western chemicals, eventually leading him to experiment with them in porcelain glazes during the 1880s. The use of Western chemicals was promoted by Dr. Gottfried Wagner, a German chemist who

MAKUDSU'S KILNS AT OTA, NEAR YOKOHAMA.

*Fig. 5.*
*Kōzan's*
*noborigama*
*(climbing kiln).*
*Photograph taken*
*during Elizabeth*
*Scidmore's visit in*
*1897. Harper's*
*Weekly 2144*
*(January 22, 1898).*

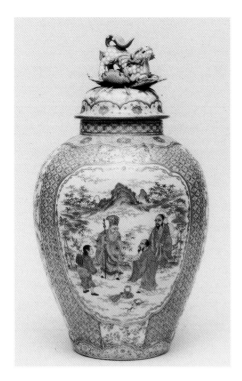

Fig. 6.
Attributed to
Kōzan. Satsuma-
style jar with lid.
Ca. 1878.
Stoneware with
overglaze colored
enamels and gold.
40 cm. The Walters
Art Gallery,
49.2092.

was invited to Japan in 1868 to help improve various indus-
tries, including cloisonné enameling, dyeing, and ceramics.
While there is no record of any direct contact between Wagner
and Kōzan during Wagner's twenty-four years in Japan, the
two were engaged in research on cloisonné enamels at the
same time, one in Tokyo, the other in Yokohama. Since they
had mutual acquaintances, it seems likely that Kōzan was at
least aware of Wagner's work.[24] By the time Kōzan turned his
attention to developing new porcelain glazes, others had
already begun similar experimentation. By the 1890s he would
be considered one of the three great masters of the period,
along with Seifū Yohei III (1851–1914) of Kyoto and
Takemoto Hayata (1848–92) of Tokyo. All three were recog-
nized primarily for their innovative glazes.

Not much is known of Kōzan's period of experimenta-
tion. In 1882 he formally made his son Hanzan (Hannosuke,
1859–1940) the head of the family. This seems to have been
the equivalent of appointing Hanzan to manage the family
business from day to day so that Kōzan could have more time
to devote to his research. Since the foreign market demand for
Satsuma-style wares decreased in the early 1880s,[25] it appears
that the Makuzu studio turned to the domestic market for
support during this period. At the first exhibition of the *Nihon
Bijutsu Kyōkai* (Japan Art Association) in 1888, Kōzan
returned to the Kyoto traditions of his youth, exhibiting
teabowls and incense containers in Ninsei and *kōchi* styles.[26]
Similarly, Hanzan's entries were inspired by traditional wares:
a Ninsei-Shigaraki dish, a Kenzan square dish with iris, a *nam-
ban* teapot, a Shigaraki hanging vase, a Korean teabowl. The
Makuzu kiln was clearly responding to a resurgence in the
popularity of the Japanese tea ceremony, following its fall
from favor in the early Meiji years.[27] The rising nationalism of
the 1880s also revived interest in Japanese cultural traditions.

The year 1889 was Kōzan's breakthrough year. In *The
Japan Weekly Mail*, a newspaper published in Yokohama for
foreign residents, a review of the annual exhibition of the
*Nihon Bijutsu Kyōkai* took notice of his new work. "Makuzu
of Ota, sends a vase as unique as it is beautiful. The glaze is a
curious transmutation of the *Hsien-hung* [red glaze] of the
Chinese Keramists, and looking out from beneath it are white
herons, delightfully drawn and indescribably soft."[28] That year
Kōzan won a gold prize at the Exposition Universelle in Paris
for his porcelains with *flammes* [sic] glazes. His entries in the
1890 Third National Industrial Exposition in Tokyo, where he
won Second Prize for Technical Innovation, continued to draw
interest for their transmutation red glazes and decoration that
seemed to float in the glaze.[29] Perhaps the highest form of
praise—imitation—came at the World's Columbian
Exposition in Chicago in 1893. Denmark exhibited porcelains
from its Copenhagen factory that tried to imitate Kōzan's
"shadowy designs drawn beneath clouded gray and rose
glazes, faint suggestions and impressions of cherry blossoms,
dragons, pine branches across the moon, and ghostly storks."[30]
They evidently paled in comparison to the real thing, and their
prices were "simply amusing in their exorbitance."[31] This style
is illustrated by a small Kōzan vase in the Walters collection
with white herons silhouetted by a misty pinkish gray glaze
(fig. 7).

Writing after her visit to Japan in 1897, Elizabeth
Scidmore summed up Kōzan's accomplishments:

> . . . the Ota kilns produced such peachblows, apple
> greens, purples, pearly grays, moonlight and powdered
> blues, imperial yellows, coral, and *sang du boeuf* as have

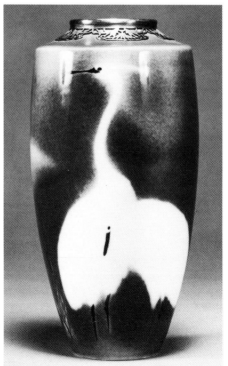

Fig. 7.
Kōzan. Small vase
with herons. Ca.
1893. Stoneware
with underglaze
pinkish gray and
blue; silver metal-
work collar. 17.8
cm. Mark: Makuzu
gama Kōzan sei
(Made by Kōzan,
Makuzu kiln). The
Walters Art Gallery,
49.1033.

imposed themselves upon native Peking experts, and in their satin-lined Chinese boxes have been hailed without a question in Europe. His peachblows are marvelous, his crackled and flambé glazes and his relief and impressed engravings in the porcelain paste are beyond praise, and his ivory whites with contorted *mangs* and lizards are miracles [fig. 8]. . . . [He] won his real laurels and place in the art world at Chicago in 1893.[32]

Indeed, he won a number of awards for vases with different glazes and for one with incised waves.[33] But the more interesting story from Chicago is that of a pair of vases which, after having won the gold prize, was destroyed as a point of honor. Each of the two-foot vases was ornamented with more than twenty-four smaller wares illustrating by example the ceramic history of China and Japan.[34] Reportedly eight years in development, due to the difficulty of firing different types of clay together, Kōzan intended to donate the vases to the Chicago exposition rather than to sell them for the $3000 they were considered to be worth. They were much admired, and a number of people tried to purchase them at a lower price, including the English curio dealer Mr. Deakin[35] and the director of the Museum of Fine Arts in Boston. Kōzan's son Hanzan, who was at the exposition as an official, refused all offers, but somehow Mr. Deakin came to believe Hanzan was going to donate them to the Boston museum in exchange for a $700 honorarium. He vented his anger in the Chicago newspapers, disparaging the foul play of the Japanese and accusing Kōzan of being a person of no honor, only out to make money. To save his father's good name Hanzan had no choice but to smash the vases to "bits and ashes"—an action that drew praise from the local press.[36]

In 1896 Kōzan was designated a *Teishitsu gigei-in* (Imperial Household Artist), the second of only five potters to receive this high honor during the fifty-four years it was granted (1890–1944).[37] Outstanding artists and craftsmen, chosen on the basis of both character and skill, received an annual stipend and a production subsidy. With this new source of funding, Kōzan set about to create another show-stopper for the next big international exposition in Paris in 1900. The result was a pair of enormous vases, taller than the average man, with a matching water basin into which two people could fit. They were decorated with bird-and-flower designs in low relief and glazed with colored enamels that required firings at four different temperatures.[38]

Having mastered glazes and massive scale, Kōzan turned toward perfecting a new technique for the Louisiana Purchase Exposition in St. Louis in 1904. The grand-prize-winning vase, which was bought by Henry Walters, depicts an old blossoming plum tree branch with a poem about a nightingale written in a calligraphic script (fig. 9). The character for nightingale is

Fig. 8. Chinese-style wares in Kōzan's showroom. Photograph taken during Elizabeth Scidmore's visit in 1897. *Harper's Weekly* 2144 (January 22, 1898).

actually perched on the branch.[39] The technical innovation lies in the calligraphy, which can be seen on the inside of the vase as if it had been written with ink that soaked through to the back of a piece of paper. This effect is achieved by a technique called *kiritōshi* (cut through), in which the shapes of the brush-written calligraphy were carefully cut out of the leather-dry porcelain body and then filled in with a plum-colored porcelain paste before glazing and firing. The seamless result produces the illusion of underglaze and an aura of impossibility.[40]

Besides these show pieces, Kōzan's studio produced a variety of porcelains between 1894 and 1915. A vase similar to the vase with irises (no. 21) was exhibited in 1894.[41] Vases of underglaze blue decor with overglaze yellow backgrounds (nos. 8, 9, 10, 11, 12, and 13), a color scheme inspired by imperial wares of the Ming and Ch'ing dynasties, were first exhibited in 1900 but may have been available to collectors as

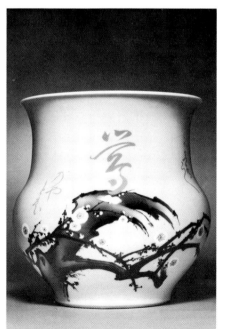

Fig. 9. Kōzan. Vase with blossoming plum and nightingale poem. Purchased at the Louisiana Purchase Exposition, St. Louis, 1904. Porcelain with underglaze blue, pink, and yellow. 31 cm. Mark: Makuzu gama Kōzan sei. *The Walters Art Gallery*, 49.1912.

early as 1897.[42] A green-glazed lotus vase in the Freer Gallery, almost identical to the vase with lotus blossoms (no. 17), was purchased in Yokohama between 1900 and 1903.[43] Vases with underglaze-blue landscape paintings (similar to nos. 1 and 2) were shown at the 1895 *Nihon Bijutsu Kyōkai* exhibition (one was awarded a silver medal), the 1900 Paris Exposition Universelle,[44] and the 1915 Panama-Pacific International Exposition in San Francisco (fig. 10). When Hanzan became Kōzan II in 1917, the studio continued to make wares along these same lines, and so, unfortunately, use of a particular technique, glaze, or style can often only be an indication of a possible early date.

As Kōzan's fame grew, so too did the orders for commissioned works. In 1905 he established a branch kiln in Karuizawa under the management of one of his top disciples, Itaka Kizan (1881–1967).[45] Karuizawa was a resort town located in the mountains northwest of Tokyo, frequented by foreign residents. The kiln, known as Mikasa-gama, was constructed under the patronage of local businessman and hotel owner Yamamoto Naoyoshi. He wanted Kōzan to produce *omiyage* (souvenir gifts) for his guests.[46] Although Kōzan officially retired in 1912, his letters, now in the possession of Kizan's son, attest to an active schedule. In one letter to Kizan, dated August 30, 1912, he wrote that he was very busy with a number of projects—a commission received from the Imperial Household Agency, preparations for an upcoming exhibition, and commissions from an art school and from some wealthy families who desired gifts to present to the new emperor. He went on to say that as soon as the Yokohama kiln firing was completed he would take an overnight train to Karuizawa, where he planned to do some painting on porcelains, decorate Kenzan-style wares, and test-fire a new glaze.[47]

It seems that Kōzan never really retired from making pottery. There are two works in this exhibition he made in 1916, the year of his death. While the clay was still soft, Kōzan himself signed the *namban* vase (no. 29) near the bottom with the words *Nanajugo okina Makuzu Kōzan saku* (Made by old man Makuzu Kōzan, seventy-five). Hanzan wrote the same characters in the box inscription for this vase and also in the one for the Kenzan-style teabowl (no. 36), adding Kōzan's *Teishitsu gigei-in* seal to both. Kōzan also worked in porcelain during his last year. There are a set of blue-and-white *sencha* cups and a small red-and-blue transmutation-glazed vase in the Perry Foundation collection with authenticating box inscriptions by Hanzan.

Hanzan officially became Kōzan II in 1917 at the age of fifty-seven. His name had first been listed professionally among the sixteen potters and painters from the Makuzu kiln who created works for the First National Industrial Exposition in 1877. He occasionally exhibited works under his own

name—in Tokyo in 1888, and in Paris in 1900—but for the most part he was one of the anonymous artisans contributing to the studio production under his father's artistic direction. Although his father never left the country, Hanzan served as an official representative of exhibitors from Kanagawa prefecture at five international expositions. On two occasions he extended his trips in order to visit pottery centers in other countries. In 1900 he visited Trent in England and Rookwood in Ohio.[48] In 1910 he made a tour of Europe, stopping at Limoges and Sèvres in France, Dresden and Meissen in Germany, Worcester and Doulton in England, Liège in Belgium, Turin in Italy, and a site in Austria.[49] He undoubtedly brought home new ideas about designs, techniques, and glazes he had seen.

After 1915, Japanese crafts were no longer included in the international expositions, but important commissions provided Hanzan with other opportunities to make large and impressive works. Three vases made under his direction remain in the imperial collection today. One is a huge celadon vase with a phoenix design, ordered by the association of Yokohama tea merchants in 1925 as a gift for the Emperor Taishō on his twenty-fifth wedding anniversary.[50] The other two were coronation gifts for the Emperor Shōwa in 1928—a large vase with blue *shishi* lions from the empress and an even larger celadon vase with phoenix handles from the mayor of Yokohama.[51] When the Prince of Wales (later King Edward VIII) visited Japan in 1922, officials from Kanagawa prefecture presented him with a large Makuzu vase depicting a Chinese scene in colored enamels.[52] The vase, which is now in the Perry Foundation collection (no. 23), was featured in a newspaper story about the prince's arrival (fig. 11).[53] These presentation gifts are rather conservative in style, reflecting an aura of Chinese inspiration, and do not reveal any new technical

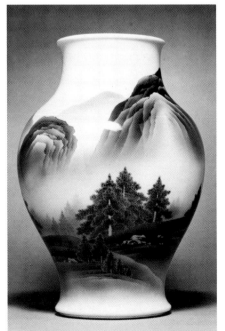

*Fig. 10. Kōzan. Vase with mountain landscape. Purchased at the Panama-Pacific International Exposition, San Francisco, 1915. Porcelain with underglaze blue. 38.6 cm. Mark: Makuzu Kōzan sei (Made by Makuzu Kōzan) The Walters Art Gallery, 49.1673.*

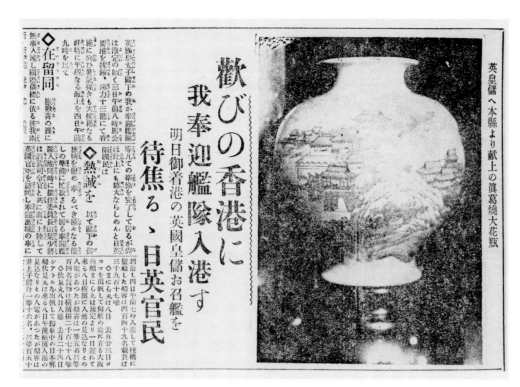

*Fig. 11.*
*"Large Makuzu ware vase to present to the British Crown Prince from Kanagawa Prefecture." Photograph from Yokohama Bōeki Shimpō (Yokohama Commerce News), April 5, 1922.*

accomplishments, simply refinements of previous ones.

Hanzan continued to participate annually in the government-sponsored art exhibitions in Japan. He served as a judge at several exhibitions and was invited to be an advisor to the revival of old Iga ware in 1923.[54] While his studio continued to make "modern" porcelains with glazes devised by Kōzan I, for example the blue-and-yellow vase with sparrows under a banana plant (no. 12),[55] it seems that a larger proportion of the production was inspired by traditional ceramic wares— Ninsei, Kenzan, Iga, *kōchi*, *shonzui*, *ko-sometsuke*, celadons, *namban*, and so forth. It is interesting to note that there is only one known record of a Ninsei or Kenzan-style object being exhibited abroad—the Ninsei-style pheasant incense burner that Henry Walters bought at the 1915 San Francisco exposition (fig 12). In 1920 there was an exclusive show of Makuzu wares at the Mitsukoshi department store in Osaka. Out of 240 works listed in the catalogue, 98 are Ninsei-style and 24 are Kenzan-style.[56] A number of stonewares in the Perry Foundation collection could easily date from this period. In fact, there is a Kenzan-style teabowl listed in the Osaka catalogue with the same descriptive characters as the box inscription for no. 37. Though it may or may not be the same teabowl, it does carry the distinction of bearing a teamaster's inscription. The box lid was inscribed by Tantansai Sōshitsu (1893–1967), who in 1923 became the fourteenth-generation master of the Urasenke tea school.[57] The apparent increase in production of more traditional styles may be related to the increasingly widespread atmosphere of cultural nationalism in the early twentieth century. It is not yet known what effect, if any, the foreign market had on Makuzu production after Kōzan I died.

When Hanzan died in 1940 at the age of eighty-two, his eldest son Kuzunosuke (1881–1945) became Kōzan III.

Practically nothing is known of the ceramic production of the Makuzu kiln during the early war years, but it was not unusual for the government to ask potters to produce such materials as ceramic insulators for the war effort. Boxes signed by Kōzan III may have been for objects left over from his father's tenure.[58] When the bombing raid on Yokohama destroyed the Makuzu workshop and killed all the workers, Kuzunosuke's younger brother Tomonosuke (1884–1959) survived because his home was not in the vicinity.[59] After the war he became Kōzan IV and tried to revive Makuzu pottery, only with a smaller single-chamber kiln and one assistant. His specialty had evidently been in kiln-firing, not in ceramic-making, and his works never attained the level of those of his predecessors.

## THE MAKUZU STUDIO

THE PRIMARY PRODUCTION PERIOD OF THE Makuzu studio spans almost seventy-five years, mainly under the leadership of two men: Kōzan I for the first forty-five years, followed by his son Hanzan, as Kōzan II, for the next twenty-five years. Over that time, the studio produced a variety of wares in stoneware and porcelain, for audiences both domestic and foreign. Because of the length of time and the different personalities, as well as the range of materials and the different markets, it is difficult to define a single style. However, by looking more closely at some of the factors that affected Makuzu production—the patrons (in a broad sense), the relationship to earlier traditions, and the introduction of new glazing techniques—we can make some general observations about the Makuzu style.

Wares were made to please particular audiences, whether foreign collectors, Japanese tea ceremony practitioners, exposition judges, or the imperial household. When the Makuzu stu-

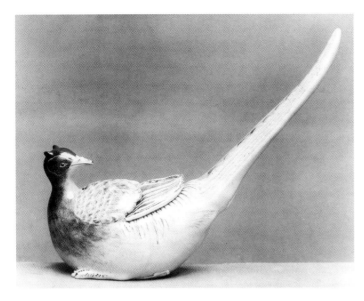

Fig. 12.
Kōzan. Ninsei-inspired pheasant incense burner. Purchased at the Panama-Pacific International Exposition, San Francisco, 1915. Stoneware with underglaze blue and black; overglaze red and gold. 30.2 cm.

Mark: Makuzu. The Walters Art Gallery, 49.878.

dio began its production with elaborately decorated Satsuma-style wares and with porcelains of exotic shape (nos. 6 and 7), it was catering to the 1870s late-Victorian taste of the foreign audience. Kōzan's foray into Chinese monochrome glazes on porcelains in the late 1880s was calculated to meet an already existing demand for such wares in the foreign market. In a review of wares at the Chicago exposition in 1893, it was complained that there were no Kōzan peach-bloom or trans-mutation glazes among the entries because "the periodic open-ings of the kiln at Ota are eagerly watched [by bric-à-brac dealers] and the successful pieces [are] incontinently carried away for export to Paris or New York."[60] Judging from descriptions and photographs of works sent to the foreign expositions, and from Western collections today, many of the decorated porcelains were produced for foreign collectors. A sampling of these decorated porcelains was exhibited in Japan at the National Industrial Expositions, but these expositions were treated as dress rehearsals for the international ones, with foreign dignitaries and businessmen in attendance. Included among the works sent to expositions were competitive entries meant to dazzle judges by their impressive size (nos. 1 and 8) or innovative technique (fig. 9).

While the main focus of Makuzu production under Kōzan I was on wares for export and expositions, during the early 1880s the market for his exports waned, and it became neces-sary to develop wares for the domestic market to ensure the viability of the business. The Japanese consumer bought ceramics primarily for making and serving everyday steeped tea or for use in the tea ceremony—teabowls for *matcha* (whisked powdered tea), cake dishes, fresh-water jars, waste-water bowls, incense burners, ash containers, incense contain-ers, and vases for the *tokonoma*. Stonewares and porcelains with styles derived from the ceramic traditions of Japan, China, Korea, and Southeast Asia were preferred. These more traditional types of wares were also sent to annual art exhibi-tions in Japan beginning in 1889 and comprised a major por-tion of the Makuzu exhibition in Osaka in 1920, four years

after Kōzan I died. In the Perry Foundation collection, a num-ber of pieces obviously made for the Japanese market still have their original wooden storage boxes (which tended to be pre-served in Japan and discarded in the West). Since these boxes were signed by Hanzan when he was the head of the Makuzu studio, they may attest to an increase in production for the domestic market during the 1920s and 1930s. Another type of domestic product, different from the tea wares, consisted of the formal gifts intended for the imperial collection. These were usually celadons or blue-and-white porcelains, produced in increasingly larger sizes over time and rarely displaying any innovation.[61]

## STONEWARES AND TRADITION

To some extent, the stylistic differences between Kōzan's stonewares and porcelains are due to the different audiences for whom they were intended. The connections with tradition, immediately understood and, in fact, demanded by Japanese consumers, were of less significance to the foreign collector. Japanese connoisseurs have always prized literary and stylistic allusions. Thus, a large number of Kōzan's stonewares incor-porate stylistic references to well-known traditions, particularly to the works of the famous Kyoto potters Ninsei and Kenzan, and to a type of rustic ware associated with Southeast Asia called *namban*.[62]

### Ninsei

Nonomura Ninsei, who was active in Kyoto in the second half of the seventeenth century, is famed as the developer of over-glaze-enamel decoration on stonewares. His designs tended to be Japanese in inspiration, as opposed to the more Chinese designs of the Arita potters, who also used overglaze enamels but on porcelain bodies. Ninsei is also distinguished for pro-ducing sophisticated *utsushi* (copies) of the wares of other kilns. His copies were not mere facsimiles but elegant adapta-tions suited to the refined tastes of the Kyoto tea men. Some

two hundred years later, Kōzan continued this tradition in his *mizusashi* (fresh-water jar for the tea ceremony), which is an *utsushi* of a type of Ninsei *mizusashi* (no. 24). The shape, which was one of Ninsei's favorites, is based upon a draw-string cloth pouch designed to hold gold dust. Kōzan used a glazing technique invented by Ninsei to imitate the appearance of the Korean *hakeme* technique. In true *hakeme*, white slip (a liquid clay) is loosely applied to a darker clay vessel with a large brush in a manner that leaves an impression of split brush hairs. Ninsei redefined the technique by reversing the relationship: he brushed iron oxide onto a white clay body.[63] Kōzan added an aura of porcelain refinement to what was originally a folk-pottery technique by substituting cobalt blue for Ninsei's iron.

A number of Kōzan's stonewares that are not outright *utsushi* have stylistic features derived from Ninsei. Objects like the vase with ivy (no. 30) and the *mizusashi* with gourd vine (no. 25) recall works by Ninsei in which a sensual elegance is heightened by the decorative contrast of opposites—luxurious gold-lined enamels, for instance, set against rough unglazed clay.[64] While Ninsei repeated a single motif to create an enameled pattern against the raw clay, Kōzan used pictorial designs from Sakai Hōitsu (1761–1828), the painter who revived the Rimpa-school tradition in the early nineteenth century. The ivy and the gourd vines, popular Rimpa subjects derived from classical literature but depicted with the refined stylized naturalism and bright colors of the Rimpa revival, closely resemble sketches Hōitsu made for lacquer designs.[65] Kōzan sharpened the contrast of textures by adding sand to his clay, perhaps in reference to the clay Ninsei developed to make Shigaraki *utsushi*. Instead of using actual clay from the area of Shigaraki, Ninsei achieved the red-orange flush and the *ishihaze* (stone-burst) effects typical of utilitarian Shigaraki wares by adding sand to a mix of Kyoto clays.[66] Unlike Kōzan, Ninsei, however, did not combine this rusticated clay with sophisticated glazes. As with the *hakeme mizusashi*, Kōzan amplified Ninsei's subtle refinements to create more dramatic contrasts.

## Namban

Kōzan's use of sandy, unglazed clay may also be taken as a reference to the imported *namban* wares revered by tea masters since the sixteenth century.[67] These were utilitarian trade-wares, mostly glazed or unglazed stoneware jars and basins, made in the countries of Southeast Asia, a region the Japanese referred to by the term *namban* (southern barbarian).[68] Japanese tea ceremony connoisseurs have traditionally categorized *namban* wares by shape or decoration. The general term "*namban*-style," as applied to Japanese-made vessels, was often used in reference to certain wares made with unglazed clay. Kōzan's unglazed and partially unglazed stonewares

make reference to several different types of *namban* styles. In the vase with white herons (no. 33), a vibrant Ninsei-style iron glaze (of the type associated with the Seto kiln) contrasts with the evenly spaced horizontal grooves incised in the unglazed portion. This distinctive texture is found on a type of unglazed *namban* ware called *shimekiri* (closed off).[69] The abstract play between the regular pattern in the clay and the irregular coloration in the glaze serves to heighten the life-like quality in the naturalistic depiction of the herons. In other works, Kōzan did not smooth over the drag lines that were made during throwing and thereby created a similar contrasting ground of horizontal lines without having to incise any. This abstract texture of lines and sandy grog sharpens the naturalistic rendering of swimming prawns on another vase (no. 28). That these prawns are so obviously alive is rather startling to those familiar with the Japanese tradition of decorating ceramics with a cooked prawn (bright red and curled up) as a symbol of longevity.[70] Interestingly, a number of these partially unglazed wares are described in Kōzan box inscriptions by the word *masagohada* (sand skin), rather than by references to *namban* or Shigaraki (see box-lids for nos. 28 and 31). Kōzan may have taken a special liking to *masago*, a poetic word for sand, because the first character is the same as the first character in Makuzu.

Another type of *namban* ware is specifically named in the box inscription for the vase with prawn handles (no. 29), which Kōzan made when he was seventy-five years old. The inscription states that it was inspired by *namban hannera*, a type elsewhere identified as a round-bottomed earthenware jar with a lid.[71] This stated source of inspiration evidently accounts more for the rough workmanship and unglazed clay body than for the shape, which actually is close to that of some of Kōzan's porcelain vases. The sculpted prawn handles, or *mimi* (ears), relate to other types of *namban* jars with ornamental lugs, like a *mizusashi* with prawns in the Nezu Institute of Fine Arts.[72] Kōzan further rusticated his vase by leaving finger marks and side dents—artful exaggerations of the down-to-earth character rightly or wrongly attributed to the *namban* potter. In the end, Kōzan elevated his pot of humble inspiration by signing his work as if it were a literati painting, with a personalized inscription on the side, "Made by old man Makuzu Kōzan, seventy-five."

## Kenzan

Ogata Kenzan (1663–1743), arguably Japan's most famous ceramic artist, started his ceramic career by reading Ninsei's pottery manual. Although he was more a ceramic designer than a hands-on potter, he was keenly interested in technical matters. He improved Ninsei's clay and glaze formulas and invented new ones to help achieve his aesthetic goal—a syn-

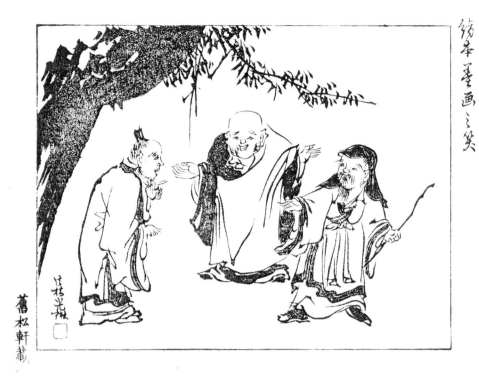

仿本墨画三笑

Fig. 13.
"The Three
Laughers" from
Kōrin Shinsen
Hyakuzu (A
Hundred Newly
Selected Pictures of
Kōrin), published
by Ikeda Koson,
1864.

thesis of painting and ceramics. Kenzan was the first in Japan to apply decoration intended to suggest actual paintings.[73] In his early period he developed underglaze pigments for low-fired earthenware that imitated the effects of materials used in painting. Kōzan's handscroll-shaped dish (no. 40) pays homage to one of Kenzan's early styles, in which the artist used an underglaze iron and cobalt mixture to evoke the black ink of a Chinese academic-style landscape painting. However, Kōzan's dish goes beyond Kenzan by assuming the shape of an actual handscroll.[74]

In his middle period, Kenzan collaborated with his brother Ogata Kōrin (1658–1716), a textile designer who became a famous painter in the Rimpa school (which derives its name from Kōrin's name). Later, this linkage of their names led to Kōrin-derived designs on ceramics being credited to Kenzan's name. Such is the case with the Kōzan teabowl which has a box inscription stating it is Kenzan-inspired; clearly the decoration is Kōrin's (no. 36). The prototype for the image of the Three Laughers depicted on the outside of the teabowl is found in the woodblock-printed book Kōrin Shinsen Hyakuzu (A Hundred Newly Selected Pictures of Kōrin), published by Ikeda Koson (1802–67) in 1864 (fig. 13).[75] The Three Laughers are old Chinese friends who were so engrossed in conversation as they walked that they did not realize one had broken his thirty-year-old Buddhist vow not to leave his mountain retreat. All they could do was laugh at the situation, which endeared them ever after to painters of humorous Zen subjects in China and Japan.[76] Kōzan added luminous gold highlights to Kōrin's austere ink painting, again demonstrating his interest in refining traditional subjects.

As part of his revival of Rimpa painting in the early nine-teenth century, Sakai Hōitsu catalogued paintings of the Ogata brothers in two books: the 1823 Kenzan Iboku (The Surviving Work of Kenzan) and the 1826 Kōrin Hyakuzu (A Hundred Kōrin Pictures). Hōitsu's publications, together with his disciple Koson's, provided sources of imagery for mid-nineteenth-century Kyoto potters working in the Kenzan tradition. Many of the compositions in these books are typical of Kōrin's decorative style, combining naturalism with bold abstract designs. However, a number of them relate more to the refined, highly decorative style of Hōitsu and his followers. Maple trees, gourd vines, waves, irises, ivy, and blossoming prunus (some-times heavy with snow) are subjects from these publications that are frequently seen on Kōzan wares. To these designs Kōzan added the painterly effect called tarashikomi, a technique used by Rimpa painters in which colors pool and run together on a wet surface. By imitating the effect of this technique in underglaze iron with overglaze enamels and gold, Kōzan created a rich texture in the tree trunks depicted on the vase with maple (no. 31) and the teabowl with prunus and snow (no. 37).

When Kōzan moved to Yokohama he encountered another Kenzan lineage, the Edo Kenzan tradition. Miura Ken'ya (1821–89), one of the major figures in the nineteenth-century Kenzan revival in Edo (called Tokyo after 1868), paid a visit to Kōzan in 1873. An account of this meeting appears in Kōzan's biography but is not mentioned in Ken'ya's. Since according to the biography the elder potter asked to become a disciple of Kōzan, the meeting could be apocryphal. However, it seems likely that the two did meet.[77] In 1871 Ken'ya moved to Yokosuka in Yokohama to establish a government-funded electric insulator factory. It went bankrupt after a year, and by 1873 he was back in Tokyo attempting to make enameled porcelain for export. Although this venture lasted only six

months, it is possible that the reason he visited Kōzan was to ask for advice. Ken'ya's activities are not recorded again until 1875, when he set up a kiln in Tokyo and returned to the profession of his earlier days, producing small earthenware curios and ceramics in the Kenzan tradition.

The most distinctive element of the style associated with Ken'ya and his disciples is a decorative formula derived from a Kenzan design referred to as *kakiwake*. This is a design in which the application of a material creates a divided field on the surface of the pot. Kenzan used white slip to create areas of different shapes for painted decoration, thereby liberating the painting from the confining shape of the vessel.[78] Ken'ya reduced this creative concept to a convention in which black glaze is applied to a section of the vessel, giving the impression that it has been dipped into the glaze at an angle. The remaining surface is then used for decoration (fig. 14). Kōzan assimilated the black glaze *kakiwake* feature of Ken'ya's style into a number of his Kenzan-style wares (nos. 31, 33, 34, 35, 38, and 39), but his imagery tended to come from the painting revivalists. In essence, he synthesized the two nineteenth-century Kenzan traditions, the Edo and the Kyoto.[79] He often compromised the *kakiwake* convention by overlapping the black glaze with part of the painting, as seen in the handwarmer with irises (no. 38). In this case, the black becomes part of the pictorial composition, suggesting pond water at the base of the irises. On other pots the black glaze assumes the pictorial quality of a ground line; an example is the sloping hill that appears on the maple tree vase (no. 31). When the dividing edge of the *kakiwake* glaze is overlapped by a repeating motif, as in the vase with rabbits (no. 32), Kōzan's works relate more to sketches of ceramic designs made by Itaya Hazan around 1901–2 (fig. 15).[80] Itaya Hazan (1872–1963) was the most famous potter of the generation to follow Kōzan I: he became an Imperial Household Artist in 1934. It is difficult to determine who influenced whom, but among the notations in

Hazan's sketchbook is one indicating that Hazan visited Kōzan in 1902. It seems highly likely that they exchanged ideas during this visit and perhaps others.

In adapting ideas from Ninsei and Kenzan, Kōzan went further than they did in creating wares that aspire to the condition of paintings. Many of Kōzan's designs are derived from pictorial, rather than ceramic, prototypes, and tend to favor one side of a vessel. He refined techniques of glazing to imitate the painter's ability to suggest textures or produce life-like images. He also introduced conceptual and aesthetic contrasts to create more dynamic works—contrasts of texture, color, material, and technique. Some of these attributes can also be found in his porcelains.

## DECORATED PORCELAINS

When he was not producing transmutation glazes or imitations of Chinese porcelain, Kōzan was decorating porcelain in a manner which, like many of his stonewares, evokes paintings. Kōzan was able to create the effects of painting on porcelain by developing new glazes and application techniques. Before imported Western chemicals became available, decorated porcelains could only be fired to high porcelain temperatures with blue cobalt under a transparent glaze. In order to prevent running, all other colors had to be applied as enamels over the transparent glaze and subsequently fired at lower temperatures. This process created a style of painting special to ceramics, in which the colored enamels exist in relief above the surface, separate from the blue beneath. New imported chemicals made it possible for Kōzan to develop high-fired colored glazes that would stay in place under the transparent glaze, thus achieving the uniform surface level of a painting on silk or paper.[81] The new chemicals also expanded the palette to include new shades of pinks, purples, greys, greens, reds, and yellows. Kōzan even experimented with imported German

Fig. 14.
Miura Ken'ya.
Serving dish for
Japanese cakes.
Courtesy of the Freer
Gallery of Art,
Smithsonian
Institution,
Washington, D.C.,
04.429.2.

cobalt, which had fewer impurities than native or Chinese cobalt and was easier to use but tended to have a brighter and harsher effect.[82] In order to mitigate these undesirable effects, he developed his own cobalt recipe, which produced a more subdued blue with soft edges.[83]

To achieve the fine gradations characteristic of Meiji traditional-style paintings, Kōzan refined a method of glaze application known as *fuki-e* (blow painting).[84] This technique made use of a small brass screen of fine mesh, onto which colored glaze was brushed. By carefully blowing through the screen, a skilled specialist created a fine spray of glaze that would imitate the subtle gradations of shading and the atmospheric washes seen in paintings. During the decorating process a paper cutout or stencil was used to mask sections where the glaze was not wanted. In the vase with a bamboo grove landscape (no. 2), Kōzan used *fuki-e* to imitate a new style of landscape painting associated with late-Meiji *nihonga* (native style) painters.[85] Around 1900, the *nihonga* artists Yokoyama Taikan (1868–1958) and Hishida Shunsō (1874–1911) developed a new painting technique, called *mōrōtai* (hazy style), where ink or colors were applied with a dry, wide-head brush made from horse-belly hairs.[86] Extremely subtle gradations created form, substance, and atmosphere. In Kōzan's landscape, cobalt blue is used as if it were ink, and there are no brush lines except those in the bamboo. The contours of hills and mountains rising out of a misty river valley were created by using torn-paper shapes with irregular edges to mask one section and then another as the cobalt spray was applied. The subtlety of this technique is readily apparent when contrasted with the visible brushwork used in the landscape painting on another vase (no. 3).[87] Though the painting style used in the landscape vases varies, they all feature compositions that encircle the vessel in a continuous manner, recalling landscape handscrolls that from beginning to end go through numerous changes of scene without a break. This convention can also be found in Ninsei's stoneware tea jars with designs of the Yoshino Mountains.[88]

Kōzan used the *fuki-e* technique not only to create atmospheric landscape paintings but also to imitate the subtle watercolor gradations common to Shijō-style naturalistic paintings.[89] Many of his vases recall the delicate painting style of one of Hōitsu's followers, Suzuki Kiitsu (1796–1858), who combined Rimpa interests in decorative qualities with Shijō sensitivities to nature. In the vase with irises (no. 21), Kōzan used *fuki-e* shading to suggest three-dimensional flower petals and to convey a sense of atmospheric depth by depicting plants disappearing into the mist as they recede away from the viewer. He showed a similar interest in creating a limited pictorial space for irises in the Rimpa-style handwarmer (no. 38). The *kakiwake* glaze creates depth through overlapping; some of the irises are in

front of the black, and some are behind it. Atmospheric depth is a characteristic more common to the landscape vases than to other subjects; however, the "fade-out" at the bottom of the iris vase (no. 21) is a feature often seen in Kōzan's decorated porcelains.[90]

Even as he took great pains to imitate the effects of painting, Kōzan also exploited the sculptural quality of clay. One of his early export styles incorporated sculpted attachments, such as the bamboo leaves and snail on the ewer (no. 6). As Kōzan developed more sophisticated glazing techniques, this tendency toward sculptural elaboration was translated into more subtle *moriage* (piled-up) accents. The slight three-dimensional effect of *moriage* is created by using slip to build up relief areas in the manner of the lacquerer. Kōzan often chose one element of a design to highlight with *moriage*, such as the white blossoms on the vase with peonies (no. 9) or the snails on the vase with *sasa* leaves (no. 18). On other vases he used this technique to embellish and accentuate the main subject, as in the white hunting hawk (no. 5). *Moriage* was used less on the stonewares. However, Kōzan's interest in creating different surface levels, expressed in porcelain with *moriage*, found a similar outlet in stonewares on which overglaze-enamel designs rise above the unglazed clay surfaces (no. 31).

Kōzan's interest in visual contrasts, especially pronounced in the stonewares with enamels on unglazed clay, can also be seen in his porcelains. It is most strongly expressed in those with underglaze blue designs surrounded by a field of bright overglaze yellow. This vibrant color scheme had originated with Ming imperial porcelain dishes featuring designs with repeating motifs. Kōzan used it with bold designs to stunning effect, as in the vase with bamboo (no. 8). The blue and yellow on another vase (no. 12) provide a surreal context for the naturalistically rendered sparrows, recalling a similar relationship in the stoneware vase bearing herons (no. 33). Although Kōzan sometimes used colors other than yellow to provide contrasting grounds for his images, only rarely did he use a contrasting texture, such as that found on the vase with irises and a water pattern (no. 20). The low-relief texture, created by incising a stylized pattern of waves through the transparent overglaze, makes the irises appear to stand out in relief.

An examination of the various techniques of decoration helps to define the Makuzu style, as does a consideration of the relationship of decoration to shape. Kōzan used three basic approaches. The arrangement most often seen is one in which the composition favors one side, with the "back" being mostly empty space. However, the viewer is enticed to look around to the "back" by the continuation of part of the composition. In the vase with a crowing rooster (no. 4), the scene with the rooster under a paulownia tree dominates one side, but the

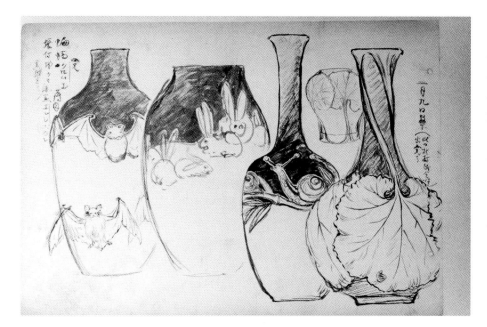

Fig. 15.

Page from Itaya

Hazan's sketchbook

Kibutsu zushō

(Drawings of

vessels), no. 88.

Ca. 1901–2.

Courtesy of the

Idemitsu Bijutsukan,

Tokyo.

leaves of the tree wrap completely around the neck, and the chrysanthemum plants behind the rooster continue to stretch part way around the middle portion. The empty space is a crucial element of the design, just as necessary here as in the hanging scrolls and folding screens that feature "one-corner" compositions balanced by expanses of empty space. Similar compositions unfold in the vase with white hunting hawk (no. 5) and the vase with blossoming lotus (no. 14). In a second type of arrangement, the decor continues completely around the vessel, revealing a different composition at different stopping places. No one side dominates; the viewer is free to stop at any point or to keep going around. Most of the landscape vases fall into this category, although the Mt. Fuji vase (no. 1) does favor a particular view of the famous mountain. There are also many vases of this type with naturalistic motifs, such as the green-glazed vase with gourd vines (no. 19). An important element in these compositions, as well as in those of the first type, is the arrangement of motifs along diagonals that dynamically move the viewer around the vessel. The third type of arrangement features a repetitive or all-over design that can be understood completely from any side. Examples are the vase with lotus and leaf design (no. 13) and the vase with snails on *sasa* leaves (no. 18). This type of arrangement is the least common—and is not seen in the stonewares, except for those with Satsuma-style designs. Like his porcelains, most of Kōzan's stonewares have compositions that favor one side. Only a few have compositions that can be viewed from any side, such as the rabbit vase (no. 32) or the iris handwarmer (no. 38).

These three compositional schemes have roots in the works of Ninsei and Kenzan.[91] What is different, and therefore modern, is the aggressive manner in which some of Kōzan's compositions thrust up into the constricted space of the neck and imply a pictorial continuation beyond the rim of the mouth (nos. 4, 8, and 14). More traditional porcelains tend to confine the composition to the body of the vase, or at least within the boundary of the foot and the mouth rims, which are often reinforced by geometric borders. The repetitive and all-over designs also have sources in Ninsei and Kenzan. Certain repetitive designs (nos. 10 and 13) seem to be exaggerations of border patterns, recalling some of Ninsei's bowls with enlarged geometric border designs.[92] Kōzan's vase with *sasa* leaves (no. 18) might have been inspired by Kenzan's box with an all-over design of pampas grass.[93] However, a more contemporary source for these designs can be found in the sketchbooks of Itaya Hazan. Starting in 1901, Hazan sketched vases with large repeating naturalistic motifs, and a design for a vase with an all-over pattern of leaves dates from 1902.[94] Such modern designs were more typical of Hazan's oeuvre than of Kōzan's.

FOLLOWING THE PARIS EXPOSITION IN 1900, there were calls for the improvement of Japanese designs on ceramics. In his report on the exposition, Kawahara Tokuryū noted that Japanese ceramics tended to present variations on earlier Japanese designs rather than reflecting the "new age."[95] Another criticism was that too many ceramics featured independent paintings rather than decorative designs. It is possible to imagine the same charge being made today with regard to Kōzan's work. One of the reasons why Kōzan's ceramics now attract interest, however, is that he did stretch the perceived limits of the medium. He is to be admired for developing new glazes and techniques and for successfully adapting paintings to ceramics in a new and dramatic way.

IN THE DIVISION OF LABOR WITHIN A LARGE WORK-shop, it was not unusual to have designated signers. The artisan signing the bottom may or may not have been involved in decorating the upper surfaces—not all painters were skilled at writing characters. Clearly, the marks were not intended to identify the specific maker, but rather the products of the Makuzu Kōzan workshop. No less than seven different hands appear among the signed objects in this catalogue, and a number of them seem to span different Kōzan generations.

In general, the porcelains have underglaze cobalt blue marks that recall the imperial Chinese reign marks of the K'ang-hsi period (1662–1722). The characters are often surrounded by a single or double square outline and sometimes encircled by an incised or blue-line double ring. A less frequently seen mark is one created with white slip in relief (no. 22). The larger works, probably made for expositions, tend to have larger and more formal-looking horizontally oriented marks with seal script characters (nos. 1 and 8). A distinctive feature under some marks, and covering the entire area inside the footrim, is a patterned texture called chattering (nos. 10 and 12). The texture is created by bouncing a trimming tool on the surface of the clay as the pot is spinning. At one time this was thought to be a characteristic of works made under Kōzan III, but it appears on a set of sencha cups in the Perry Foundation collection which has a box signed by Kōzan II saying that Kōzan I made them in 1916.

There are four types of impressed "Makuzu" marks in this exhibition. The large oval mark is similar to one used by Makuzu Chōzō, Kōzan's father (nos. 29 and 35).[96] The small oval mark is frequently found on small traditional objects made for chanoyu tea ceremonies, like teabowls, dishes, and incense containers (nos. 37 and 40). The large gourd-shaped mark appears on slightly larger objects, such as fresh-water jars, vases, and handwarmers (nos. 24, 28, and 39).[97] And a square mark in several different sizes is frequently used on celadon-glazed objects and small porcelains (no. 26). Most of these marks seem to be used across the generations. However, there is as yet no evidence that the large gourd-shaped mark was used during Kōzan I's lifetime. In fact, the box inscriptions associated with these marks point to a time after Kōzan II became master.

WHILE THE MARKS ON THE CERAMICS THEMSELVES provide little information to help with dating, the inscriptions on the wooden boxes that were made to store the ceramics offer more valuable clues. It was the responsibility of the workshop master to inscribe each box lid with a brief description of the object followed by his signature and seal. If each generation had used a different name, the historian's task would be simple, but since the professional name Makuzu Kōzan was inherited with the business upon the death of the preceding master, the problem becomes one of differentiating the calligraphic hands of the different Kōzans. Of the boxes studied in preparation for this catalogue,[98] most appear to have been signed by Kōzan II (from 1916–40) and some by Kōzan III (from 1940–45). Boxes signed by Kōzan I seem to be scarce. This suggests, on the one hand, that there could be a number of his works in private Japanese collections, and on the other, that most Western collectors threw away what was considered packing material.[99] There is only one inscription in this exhibition that comes close to the style of Kōzan I, and it may be a deliberate attempt to imitate his hand on a remade box (no. 14).

The following groups suggest a signature chronology for sixteen box inscriptions belonging to objects in this exhibition. They are based on a preliminary study that included ten additional boxes from the Perry Foundation collection, six boxes in the collection of Kurihara Naohiro,[100] a box in the Saint Louis Museum of Art, and signed paintings and letters by Kōzan I and II.[101] Groups A through E are arranged in an order to suggest a progressive change in Kōzan II's signature style over twenty-four years (1916–1940). Group A dates to his earliest years as master starting in 1916. It includes a number of inscriptions in which he attributes the work to Kōzan I and often uses his father's Teishitsu gigei-in seal. Group E dates to his last years and includes two inscriptions dated 1935 and 1938 that are not in this exhibition.[102] Group F dates to the period 1940–45 when Kōzan III was signing boxes.

Group A (nos. 29, 35, 36)
Group B (nos. 38, 39, 40)
Group C (nos. 24, 37)
Group D (nos. 28, 33)
Group E (nos. 12, 26, 27, 34)
Group F (nos. 10, 31)

[1] Dresser (1882), p. 387.

[2] Scidmore (1898), p. 86. I would like to thank Beth Garnier for finding this valuable source.

[3] Shugio (1910), p. 286.

[4] Scidmore (1898), p. 86.

[5] Arishima Ikuma, "Omoide no waga" (My memories), *Chūō kōron* (Nov. 1965), p. 222, quoted by Itaka Kizan II in Yokota (1986).

[6] Itaka Kizan II writes of his father's memories of Kōzan in an essay in Yokota (1986).

[7] Unless otherwise indicated, all information about Kōzan's life and activities up to 1889 is derived from *Makuzuyaki sōzōsha Miyagawa Kōzan ō-den* (ca. 1889). This is a woodblock-printed book in the papers of Edward S. Morse, Peabody & Essex Museum, Salem, Mass., brought to my attention by Richard Wilson. (More information on the Morse archives will be published in a forthcoming article by Richard Wilson in the *American Ceramic Circle Bulletin*.) There is no author or publisher listed, and the date 1889 is derived from the text. According to this biography, the family originally descended from the Asai family in Omi province. An ancestor named Chōkansai moved the family to Miyagawa-mura in Kyoto. Evidently the later family name "Miyagawa" came from their association with this location.

[8] It was not unusual in the Edo period for feudal lords to invite professional potters to operate small "garden kilns" (*niwayaki*) within the spacious gardens attached to their residences.

[9] Technically Chōzō is the first-generation Kōzan, but he seems to have rarely used the name Kōzan, preferring Chōzō. Thus, his son Toranosuke assumed the art name Kōzan upon his death and came to be referred to as "*shodai* Kōzan", first-generation Kōzan.

[10] Most famous artists in Japan have at least one "precocious child" anecdote in their biographies.

[11] Giryō (dates unknown) was the son of Geppō (1760–1839), the head priest at Sōrin-ji temple, who had studied *nanga* painting with Ikeno Taiga (1723–76). Geppō was also known as Taigadō III when he took over Taiga's old Makuzuan house after Aoki Shukuya died. He painted landscapes and *kachōga*. Geppō's other son Seiryō (d. 1869) became Taigadō IV. In 1869 Giryō became head priest of Sōrin-ji temple, which was located in the Makuzu neighborhood. Paul Berry kindly provided me with this information.

[12] This description comes from an interview with Kōzan in *Bijutsu shimpō* (September 1911), p. 357. He also says it was the first time he tried his hand at *sencha* wares. Clare Pollard provided this information.

[13] For information about Mushiage, see *Nihon yakimono shusei*, vol. 9, pp. 109–10. There are two teabowls in the Morse collection in the Museum of Fine Arts, Boston that have Kōzan's "Makuzu" mark and a "Mushiage" mark. See Morse (1979), p. 55, nos. 500, 501.

[14] One frequently sees Satsuma and Kyoto wares incorrectly identified as faience or earthenware because the clay body appears "soft," lacking the degree of vitrification seen in other stonewares. This is because they have high-alumina (high kaolinic) bodies. However, they are coated with feldspar-ash glazes which can only mature at temperatures over 1200 degrees centigrade, well within stoneware temperature range. The overglaze enamel decorations are later applied and fired at temperatures between 600 and 800 degrees. I would like to thank Richard Wilson for helping to clarify this.

[15] After his elder brother died, Kōzan married his wife, and it is assumed that Hanzan was his brother's two-year old son, whom Kōzan adopted as his heir. The Makuzu kiln in Kyoto was taken over by another branch of the family when Kōzan left for Yokohama. Yoshiō Kōsai (1846–1922) had worked at the kiln from the days when Chōzō was the head. The kiln is now headed by his grandson, the seventh-generation Kōsai, and continues to produce mostly copies of Chōzō's wares.

[16] Evidently, not all of Kōzan's Satsuma-style wares were signed, leading some collectors to believe they were purchasing "Old Satsuma." See Bowes (1890), p. 116. The covered jar in figure 6 has no mark, but the name "Makusu" (a common misspelling of Makuzu) is written in pencil on the underside of the lid in what is believed to be Henry Walters' handwriting. There are a number of ceramics in the Walters collection with pencil-written identifications probably made by Henry, based on information received from the dealer at the time of purchase.

[17] The Victoria and Albert Museum has a Kōzan vase (no. 308-1879) bought in 1879 with high-relief decoration of a hawk on a blossoming plum branch, illustrated in Kerr (1986), fig. 4. Other vases from this period are illustrated in Hida (1989), p. 65.

[18] Audsley and Bowes (1881), pp. 246–47.

[19] Dresser (1882), p. 387.

[20] Brinkley (1904), pp. 405, 416.

[21] However, there was one Japanese critic who felt Kōzan went too far in imitating reality too precisely, just to dazzle his audience. Yamamoto Goro, *Meiji junenkai naikoku kangyo hakurankai hōkokusho, tōjibu, Kanagawa-ken* (Report on the Second National Industrial Exposition, ceramics section, Kanagawa prefecture), 1877, quoted in Hida (1989), p. 4.

[22] This company was formed in 1874 by two dealers to promote and sell Japanese crafts abroad. With the help of government grants they supported individual artisans and employed many more in their own factories. They were one of the major exhibitors at the international expositions and set up branch stores in New York in 1877 and Paris in 1878 as permanent outlets for their products. The company declined after 1882 and went out of business in 1891. See Uyeno (1958), pp. 114–15.

[23] Kōzan exhibited eleven works of cloisonné on ceramics at the Second National Industrial Exposition in 1881. Hida (1989), p. 78.

[24] There are several possible connections through Sano Tsunetami of the Kiritsu Kōshō Kaisha. Hida (1989), p. 4.

[25] Ibid, p. 3, and Scidmore (1898), p. 86.

[26] *Kōchi* is the Japanese name for a type of pottery believed to be from Cochin China (an area in Northern Vietnam) but probably made in the region of Canton. The wares imported to Japan were mostly small containers for incense and medicine, decorated with molded or incised designs and colored with low-fired green, purple, and yellow enamel glazes applied directly to the clay surface.

[27] For a discussion of *chanoyu* in the early Meiji period, see Guth (1993), pp. 72–75.

[28] *The Japan Weekly Mail*, 4 May 1889, p. 430. The Chinese glaze *hsien-hung* is a blood red or bright red.

[29] Ibid, 12 April 1890, pp. 372–73.

[30] Scidmore (1898), p. 86.

[31] *The Japan Weekly Mail*, 13 January 1894, p. 45.

[32] Scidmore (1898), p. 86.

[33] He won awards for two peachblow vases with dragon designs, a vase with dragon and waves pattern, a vase with plum-blossom decoration on a pale yellow ground, and a collection of one hundred small solid-color porcelains exhibited by the dealer Hayashi Tadamasu. *The Japan Weekly Mail*, 13 January 1894, p. 45.

[34] These were not the first exposition works to present courses in art history. At the 1890 Third National Industrial Exposition in Tokyo, Namikawa Sosuke exhibited a two-fold screen, seven feet tall and three years in the making, that recreated six famous Japanese paintings in cloisonné enamels. *The Japan Weekly Mail*, 29 March 1890, p. 322.

[35] He is most likely the dealer of Deakin Bros. & Co., Art Curio Dealers, Grand Hotel Annex and 16 Bund, Yokohama. The Deakin Bros. name is also associated with a traveling "Japanese Village" at the Thirteenth Cincinnati Industrial Exposition in 1887. Volpe (1988), p. 71.

[36] This story is recounted from a Japanese source, as I have not yet found any references to this incident in the Chicago newspapers. *Kyoto bijutsu kyōkai zasshi* (1896), pp. 10–12.

[37] The other potters designated *Teishitsu gigei-in* were Seifū Yohei in 1893, Itō Tōzan and Suwa Sōzan in 1917, and Itaya Hazan in 1934. In the entire crafts category, including ceramics, textiles, lacquer, metalwork, and cloisonné, there were only twenty-four artisans named. By 1944 a total of seventy-nine artists and artisans would receive this honor, more than half of them painters. Clare Pollard assisted in compiling these statistics.

[38] This set was purchased for the imperial collection but was destroyed during World War II. Yokota (1986), p. 5 of his unpaginated essay. For a photograph, see Hida (1989), p. 3.

[39] The poem was written by Ki no Naishi, the daughter of the famous poet Ki no Tsurayuki (ca. 872–945) on the occasion when her favorite plum tree was selected to replace a dying one in the emperor's garden. She addressed a poem to the emperor expressing her sadness with such eloquence that the emperor allowed it to remain in her garden: *Choku nareba itomo kashikoshi uguisu no yado wa to towaba ikaga kotaemu* (Since my Lord commands, what can one do but obey? But the nightingales, when they ask about their nests—whatever can I tell them). Translation from Robert Wood Clack, *The Soul of Yamato: An Historical Anthology of Japanese Poetry*, 2 vols. (New York: Gordon Press, 1977) vol. 1, p. 157. Clare Pollard deserves credit for finding the poem and translation. The lines of poetry on the Walters vase are followed by the author's identification *Ki no Tsurayuki onna* ("daughter" of Ki no Tsurayuki).

[40] This painstaking technique was probably not economically viable, since there is only one other example known to exist, which is a smaller version of the St. Louis vase. See Yokota (1986), no. 64.

[41] Illustrated in Hida (1989), p. 2.

[42] On her visit to Kōzan's studio in 1897, Elizabeth Scidmore reported an imperial yellow glaze to be in Kōzan's repertoire. Scidmore (1898), p. 86. Hida finds a listing in the 1900 *Nihon Bijutsu Kyōkai* exhibition for a blue and yellow vase that was purchased for the imperial collection.

[43] Freer Gallery of Art Study Collection FSC-P-4253, gift of Mrs. Herbert C. Blunck. Her mother acquired the vase while living in Yokohama between 1900 and 1903.

[44] Illustrated in Thomson (1901), p. 283 and more recently in *Christie's New York* (October 17, 1989), no. 471.

[45] Itaka Kizan joined the Kōzan studio in 1903 and won a silver prize at the St. Louis exposition in 1904. He was introduced to Kōzan by his father-in-law, who sold glaze materials in Kanazawa and had studied under Wagner in his youth. The connection between the Mikasa kiln and the Makuzu kiln did not continue after Kōzan's death in 1916. In 1921 Kizan opened a kiln in Meguro, Tokyo. His son Kizan II continues to work as a potter in Tokyo. Hida (1989), pp. 6 and 67.

[46] There is a celadon incense burner with a sculpted *shishi* lid in the collection of the Tokyo dealer Kurihara Naohiro that has a box inscription saying it was made at Mikasa-gama. Illustrated in Kurihara (1994), pp. 77–78.

[47] The letter is published in Itaka Kizan, "Kōzan sensei no koto nado" (Thoughts on Kōzan), in Yokota (1986), unpaginated.

[48] Hanzan had probably been invited to visit Rookwood by Kataro Shirayamadani (1865–1948), a Japanese decorator who had been working

there since 1887. He was originally from Kanazawa and was part of the Deakin Bros. traveling "Japanese Village" at the 13th Cincinnati Industrial Exposition when he was offered a position at Rookwood Pottery. If Hanzan did not meet him at the 1893 Chicago exposition, they probably met while Kataro was in Japan in 1894 studying glazing techniques. Volpe (1988), p. 73.

[49] Hida (1989), p. 5.

[50] Illustrated in Kunaichō (Jan. 4 – Feb. 20, 1994), no. 15.

[51] Illustrated respectively in Kunaichō (Jan. 4 – Feb. 20, 1994), no. 16 and Hida (1989), no. 96.

[52] The most interesting account of the Prince's trip to Japan is in *A King's Story: The Memoirs of the Duke of Windsor* (New York: G. P. Putnam's Sons, 1947), pp. 180–82. There is no mention of this gift in the Royal Archives, suggesting that Edward VIII probably regarded it as a personal gift. At some point, it was then given away or sold.

[53] *Yokohama Bōeki Shimpō* (Yokohama Commerce News), 5 April 1922. Credit for finding this obscure source goes to Kanisawa Kōzō, who was unaware of the current connection to the Perry Foundation collection. Clare Pollard brought it to my attention. A vase with a similar landscape, but with a different cloud pattern, is illustrated in *Nihon bijutsu kyōkai hokoku* 57, 1917.

[54] This was sponsored in Ueno-Iga, Mie prefecture by the politician Kawasaki Katsu.

[55] The technical refinement of the painting on this vase with sparrows and banana tree is comparable to a vase exhibited in the Twelfth Teiten exhibition in 1931, illustrated in Hida (1989), no. 99.

[56] Mitsukoshi (1920), table of contents. I was only able to see an old xerox of this catalogue in which the photographs of the works had already faded.

[57] It seems very likely that the box for this teabowl was remade to allow the tea master to inscribe the inside of the lid. Ordinarily, Kōzan inscribed boxes on the inside lid. In this case the wood from the old lid, with his signature, was used for the bottom of the new box with his inscription visible on the outside. This explanation was suggested by Richard Wilson.

[58] Kurihara (1994), p. 79.

[59] The bodies of the family members and six workers were found in the remains of the *noborigama* (climbing kiln) where they had taken cover. Miyagawa (1988), p. 96.

[60] *The Japan Weekly Mail*, 4 March 1893, p. 255.

[61] It has been suggested to me by Itaka Kizan II that Kōzan did not receive his *Teishitsu gigei-in* distinction for the kinds of works he produced for export, of which most Japanese knew very little, but, rather, for his conservative wares derived from Chinese and Korean types and, more importantly, for his business success.

[62] Kōzan even carried these stylistic references into his inscriptions on the wooden storage boxes for these pieces. When he described a work inspired by Ninsei he wrote Ninsei's name in the thin, elegant style of calligraphy associated with Ninsei's aristocratic patrons (see box-lid for no. 24). Likewise, Kenzan's name was written in a bold fashion, imitating the style of his signature (see box-lids for nos. 36, 37, 38, 39). Richard Wilson finds the Kenzan signature to be closest to the style of Kenzan IV (1851–1923).

[63] For an example of Ninsei's *hakeme*, see Hayashiya (1974), p. 63, no. 76.

[64] Ninsei's most famous works in this style are three teabowls illustrated in Kuwahara (1976), nos. 47, 49, 53.

[65] Hōitsu's sketches for lacquerware designs are preserved in the numerous design books of lacquer artist Hara Yōyūsai (1772–1845) that are now in collections around the world. For the specific designs of ivy and gourd vines that relate to Kōzan's work, see illustrations from the book in the collection of the Yamato Bunkakan, Nara in Nakamura (1980), pl. 128-A on pp. 29, 40.

For more information on the design books of Yōyūsai, see Heinz Kress. "The Yōyūsai Pattern Book," *The Journal of the Walters Art Gallery* 52 (1994), in press.

[66] Cort (1979), pp. 186–9. For illustrations of Ninsei's Shigaraki wares, see Hayashiya (1974), p. 65.

[67] For information on the history of *namban* ceramics in Japan, see Cort (1993).

[68] The origins of these wares include Thailand, Vietnam, Cambodia, Burma, and coastal southern China.

[69] See Cort (1993), fig. 33.

[70] The prawn or *ebi* symbolizes the wish that one may live so long that one's back becomes as bent as that of a prawn.

[71] For discussions and illustrations of *hannera* type jars, see Cort (1993), p. 40, fig. 42, and Nezu (1993), pp. 118–119, figs. 65, 115, 117.

[72] Nezu (1993), no. 60.

[73] For illustrations, see Wilson (1991), pp. 236–37.

[74] The fashion for pottery imitating non-pottery objects began in Kyoto in the mid-seventeenth century.

[75] The painting on which this woodblock reproduction may be based is in the Tōyama Kinenkan Foundation, illustrated in Honolulu (1980), no. 21.

[76] Hui-yüan was the Buddhist priest, and his visiting friends were the learned sages Tsu Hua-ming and Lu Hsiu-ching.

[77] For more information on Ken'ya and the Edo Kenzan tradition, see Wilson (1991), pp. 170–85. For illustrations, see Wilson and Ogasawara (1992), vol. II, pp. 184–90.

[78] For illustrations, see Wilson (1991), nos. 66, 67.

[79] Kōzan adopted one more Ken'ya convention for his Kenzan-style wares—the white-slip and iron signature patch (see marks for nos. 30, 35, 36, 37, 38, 39). Kenzan wares were occasionally signed in this manner, but the nineteenth-century Edo Kenzan tradition used this signature patch more like a trademark than a signature.

[80] For more illustrations of this style from Hazan's sketchbook, see Idemitsu (1986), nos. 90, 191, 227, 228, 250. It was not until 1913 that Hazan produced a vase with decoration based on one of these sketches.

[81] According to Itaka Kizan II, uranium oxide was one of the new chemicals imported in the Meiji period that potters experimented with in glazes. Itaka (1994), p. 22. This was a chemical used in Western glazes up to 1942, when restrictions were placed on the use of uranium. It could be used at high temperatures to produce cool lemon-yellows or a black in reduction fire. At lower temperatures it could produce bright red and coral glazes in combination with a high-lead glaze. There is evidence that Kōzan used uranium oxide in some of his glazes. Beth Garnier's master's thesis will discuss the chemicals used in Kōzan's glazes, including results from X-ray fluorescence testing conducted on some Kōzan pots in the Freer Gallery of Art study collection. Her results were not available at the time of this writing. See Garnier (1994).

[82] Criticisms of the new cobalt appear in *The Japan Weekly Mail*, 5 July 1890, p. 20 and Scidmore (1898), p. 85. Bernard Leach compares the use of European cobalt to Chinese and Japanese cobalt in *A Potter's Book* (New York: Transatlantic Arts Inc., 1939 [Fourth American edition, 1949]), pp. 128–29.

[83] There is a box inscription in which Kōzan refers to the use of "Makuzu-researched blue." Hida (1989), p. 5. The soft-edged look of Kōzan's blue underglaze appears to be the result of the color running slightly during firing. This is especially noticeable on vertical surfaces. The effect is not noticeable on Kōzan's early porcelains, when he was still using traditional cobalt mixtures.

[84] This technique is described in Saga (1983), p. 91.

[85] *Nihonga* refers to traditional-style painting as opposed to *yōga* which is Western-style painting. *Nihonga*'s main champion was Okakura Tenshin (1862–1913), who established the *Nihon Bijutsu-in* (Japan Art Academy) in 1898 to promote traditional styles in opposition to *yōga*. It is not known when Kōzan befriended him, but Okakura was invited to give lectures to the *Yokohama Tōga Kyōkai* (Yokohama Ceramic Painting Association), founded in 1897. And Kōzan was invited to join *Nihon Bijutsu-in*. Yokota (1986), unpaginated.

[86] Private communication from Victoria Weston of Boston University, a Yokoyama Taikan specialist.

[87] The technique of shading with a wet brush in which individual brush-strokes are sometimes visible is called *bokashi*.

[88] For illustrations, see Hayashiya (1974), pls. 3, 7.

[89] The Shijō school was a branch of the eighteenth-century Maruyama school which was characterized by a stong sense of realism and the use of light wash colors.

[90] This "fade-out" feature, accomplished by a skillful manipulation of the *fuki-e* technique at the bottom of a composition, seems to appear mostly on works dating from the 1890s to at least 1915. Hanzan's later porcelains do not seem to make use of it, but more research is needed to determine when the style changed.

[91] Ninsei's tea jar with prunus tree displays a "one-sided" composition that wraps part way around the sides, and his tea jar with wisteria features a design that varies in composition as it wraps completely around the pot. These jars are illustrated respectively in Hayashiya (1974), pls. 2, 1.

[92] For illustration, see Hayashiya (1974), pl. 22.

[93] For illustration, see Wilson (1991), fig. 237. This box is in the Suntory Museum of Art.

[94] For illustrations, see Idemitsu (1986), figs. 198, 199, and 200 for repeating motifs and fig. 249 for all-over design.

[95] It is presumed he was referring to the Western style of *art nouveau*. Uyeno (1958), pp. 149–50.

[96] Miyagawa (1988), pp. 22, 119. It appears most frequently as a seal in Chōzō's box inscriptions.

[97] A similarly shaped seal appears on a box inscription by Yoshiō Kōsai (1846–1922), who took over the Makuzu kiln in Kyoto when Kōzan left for Yokohama. See Miyagawa (1988), p. 44, no. 60.

[98] I was not able to see boxes in the Kanagawa Kenritsu Hakubutsukan due to a renovation project in 1994. This was unfortunate because they have the largest collection of Kōzans in Japan. For a more complete study of box inscriptions we must await Clare Pollard's dissertation.

[99] Examples of works with boxes inscribed by Kōzan I are: (1) an incense container recently acquired by the Saint Louis Art Museum with an inscription dated 1908; (2) an incense burner in Kurihara Naohiro's collection with an inscription stating it was made at Mikasa kiln [1905–16], illustrated in Kurihara (1994), p. 78; (3) a figure of Kannon with the *Teishitsu gigei-in* seal [1896–1916] in the inscription, illustrated in *Christie's London*, 14 June 1989, no. 86; and (4) a teabowl which may date from Kōzan's Kyoto period, illustrated in Miyagawa (1988), p. 47, no. 66.

[100] Illustrated in Kurihara (1994): 78–9.

[101] Illustrations of paintings and letters are in Hida (1989). Itaka Kizan has additional letters in his possession.

[102] See Hida (1989), p. 48 for an inscription on the bottom of a vase dated 1935. A small white stupa in the Perry Foundation has a box inscription dated 1938.

# SELECTED CHRONOLOGY

1842  Miyagawa Kōzan I born (Jan. 6), given name Toranosuke

1851  Miyagawa Chōzō (Kōzan's father) establishes kiln in Makuzugahara, Kyoto; the wares from this kiln are named "Makuzu-yaki," and he receives the art name "Kōzan"

1853  Commodore Matthew Perry arrives in Japan

1854  Treaty between Japan and U.S.A. ends seclusion

1859  Yokohama port opens; Kōzan II (Hannosuke or Hanzan) born (June 1)

1860  Chōzō dies (March 20); elder brother Chōhei dies (July 10); Kōzan becomes head of family at age 18

1866  Shogunate orders *sencha* tea set as gift for emperor

1868  Kōzan invited to Mushiage kiln in Bizen province; Dr. Gottfried Wagner arrives in Japan; restoration of Imperial rule

1869  Imperial capital transferred from Kyoto to Tokyo

1870  Kōzan moves to Yokohama with wife, Hanzan, and four disciples

1871  Kōzan opens Makuzu kiln in Nishi-Ota (June); trains local people to become pottery painters; feudal fiefs abolished, and the country is redivided into prefectures

1872  First railway between Tokyo and Yokohama opens

1873  Vienna International Exposition (gold medal); meets Miura Ken'ya

1874  Export company Kiritsu Kōshō Kaisha is established

1876  Philadelphia Centennial Exposition (bronze medal)

1877  First National Industrial Exposition, Tokyo (Imperial award); receives order from Kiritsu Kōshō Kaisha

1878  Paris Exposition Universelle (gold medal)

1879  Sydney International Exposition (first prize); *Ryūchikai* art society is established, will become *Nihon Bijutsu Kyōkai* (Japan Art Association) in 1887

1880  Melbourne International Exposition (first prize)

1881  Second National Industrial Exposition, Tokyo; Kōzan exhibits ceramics with cloisonné enamels; Kōzan III (Kuzunosuke) born

1882  Hanzan becomes head of family; Kōzan begins period of glaze experimentation

1883  Amsterdam International Exposition (silver medal)

1884  Kōzan IV (Tomonosuke) born

1888  Spain International Exposition (silver medal); Kōzan begins to exhibit annually in the *Nihon Bijutsu Kyōkai* exhibitions

1889  Paris Exposition Universelle (gold medal); Kōzan exhibits works with transmutation glazes; Miura Ken'ya dies

1890  Third National Industrial Exposition, Tokyo (second prize for technical innovation, transmutation glaze)

1892  Wagner dies; one-hundred-fifty-year commemoration ceremony for Kenzan held at Zen'yōji, Tokyo

1893  World's Columbian Exposition, Chicago (gold medal); Hanzan attends exhibition as an official of Kanagawa prefecture, destroys award-winning vases; Denmark exhibits Copenhagen imitations of Makuzu wares

1894  Outbreak of Sino-Japanese war

1895  Fourth National Industrial Exposition, Kyoto (second prize for technical innovation)

1896  Kōzan is designated *Teishitsu gigei-in* (Imperial Household Artist)

1897  Elizabeth Scidmore visits Makuzu kiln; *Yokohama Tōga Kyōkai* (Yokohama Ceramic Painting Association) is established

1898  Okakura Tenshin establishes *Nihon Bijutsu-in* (Japan Art Academy), and Kōzan becomes a member

1900  Paris Exposition Universelle (grand prize); Hanzan attends exhibition as an official, visits potteries at Trent, U.K. and Rookwood, U.S.A. on his way home

1902  First visit from Itaya Hazan

1903  Fifth National Industrial Exposition, Osaka; Itaka Kizan begins working at Makuzu kiln

1904  Louisiana Purchase Exposition, St. Louis (grand prize); outbreak of Russo-Japanese war

1905  Kōzan establishes a branch kiln, Mikasa-gama, at Karuizawa under the management of Itaka Kizan

1910  Japan-British Exposition, London; Hanzan attends exhibition as an official, visits European potteries at Limoges, Sèvres, Dresden, Meissen, Worcester, Doulton, Liège, and Turin on the way home

1912  Kōzan retires, hands business over to Hanzan; Emperor Meiji dies (July 30); receives commissions for Emperor Taishō's coronation

1915  Panama-Pacific International Exposition, San Francisco

1916  Kōzan dies (May 20), 75 years old by Japanese count

1917  Hanzan officially becomes Kōzan II at age 57 (May)

1920  Exhibition of Makuzu wares at Osaka Mitsukoshi department store

1922  Vase commissioned by Kanagawa prefecture as gift for the visiting Prince of Wales

1923  Hanzan advises on the revival of old Iga ware; Great Kanto earthquake

1925  Vase commissioned by the association of Yokohama tea merchants as a gift for the emperor's 25th wedding anniversary

1928  Receives commissions for Emperor Shōwa's coronation

1940  Hanzan dies (April 19), age 82 by Japanese count; Kuzunosuke (Kōzan III) becomes head of Makuzu kiln

1941  Outbreak of Pacific War, World War II

1945  Makuzu kiln destroyed in bombing raid on Yokohama (May 29); Kuzunosuke dies (age 64) with family and workers

Late 1940s  Tomonosuke assumes the title Kōzan IV; tries to revive Makuzu kiln on a smaller scale

1959  Tomonosuke dies (July 27), age 75

# BIBLIOGRAPHY

*Note*: English titles are used verbatim for Japanese-language articles, journals, or books wherever they are supplied in the publication.

Audsley, George Ashdown and James L. Bowes. *Keramic Art of Japan*. London: H. Sotheran & Co., 1881.

Baekeland, Frederick and Robert Moes. *Modern Japanese Ceramics in American Collections*. New York: Japan Society, Inc., 1993.

Bowes, James Lord. *Japanese Pottery, with Notes Describing the Thoughts and Subjects Employed in its Decoration, and Illustrations from Examples in the Bowes Collection*. Liverpool: E. Howell, 1890.

Brinkley, Captain F. *Keramic Art*. Japan, Its History Arts and Literature series, vol. 8. Boston and Tokyo: J. B. Millet Co., 1904.

Cort, Louise Allison. "Buried and Treasured in Japan: Another Source for Thai Ceramic History." In *Thai Ceramics: The James and Elaine Connell Collection*, pp. 27–44. New York: Oxford University Press, 1993.

———. *Shigaraki, Potters' Valley*. Tokyo, New York and San Francisco: Kodansha International Ltd., 1979.

Dresser, Christopher. *Japan, Its Architecture, Art, and Art Manufactures*. London: Longmans, Green, and Co.; New York: Scribner and Welford, 1882.

*Exposition Universelle Internationale de 1878, à Paris. Catalogue Officiel. Tome I. Groupe I, Oeuvres d'Art.* Paris: Commissariat Général, 1878.

*Fine Arts Magazine containing Illustrations and Descriptions of Products of The Paris World Exposition Exhibiter's Union, Extra issue no. 2.* Tokyo: Gahosha, 1900.

Garnier, Beth. "Meiji Period Artistic Innovations in the Ceramics of Miyagawa Kōzan (1842–1916): From Satsuma to Porcelain" Master's thesis, University of Maryland, in progress.

Guth, Christine M. E. *Art, Tea, and Industry: Masuda Takashi and the Mitsui Circle*. Princeton, N.J.: Princeton University Press, 1993.

Hayashiya Seizo. *Kenzan, Ninsei*. Nihon no Tōji series, vol. 12. Tokyo: Chūō Koronsha, 1974.

Hida Toyojiro. *Minato Yokohama ga sodateta Makuzuyaki* (Makuzu ware cultivated in the harbor city of Yokohama). Yokohama: Yokohama-shi kyōiku-i inkai, 1989.

Honolulu Academy of Arts. *Exquisite Visions: Rimpa Paintings from Japan*. Honolulu: Honolulu Academy of Arts, 1980.

Idemitsu Bijutsukan, comp. *Itaya Hazan, Idemitsu Bijustukan zohin zuroku* (Itaya Hazan, catalogue of the collection of the Idemitsu Museum). Tokyo: Idemitsu Bijutsukan, 1986.

Itaka Kizan, Hida Toyojiro, and Clare Pollard. "Meiji kindai tōgei no makuake" (The beginning of Meiji modern ceramics). *Me no me* 213 (July 1994): 13–28.

*Japan and Her Exhibits at the Panama-Pacific International Exhibition 1915*. Tokyo: Hakurankai Kyokwai, 1915.

Kanagawa Kenritsu Hakubutsukan, comp. *Miyagawa Kōzan sakuhin mokuroku* (Catalogue of the works of Miyagawa Kōzan). Yokohama: Kanagawa Kenritsu Hakubutsukan, 1989.

Kawahara Masahiko. *Ninsei*. Nippon Tōji Zenshū series, vol. 27. Tokyo: Chūō Koronsha, 1976.

Kerr, Rose. "Some Satsuma and Satsuma-style Wares." *Orientations* 17 (December 1986): 47–52.

Kunaichō Sannomaru Shōzōkan, comp. *Keiga ni yosete* (Art of felicitations). Tokyo: Benridō, Jan. 4 – Feb. 20, 1994.

———. *Kachō no bi: Jakuchū kara kindai made* (Birds and flowers in art: From Jakuchū to modern age). Tokyo: Benridō, March 8 – June 12, 1994.

Kurihara Naohiro. "Makuzu Kōzan to makoto no kokusaika" (Makuzu Kōzan and true internationalism). *Kobijutsu rokushō* 13 (July 25, 1994): 77–81.

*Kyoto bijutsu kyōkai zasshi* 55 (December 28, 1896): 8–13.

*Makuzuyaki no sōzōsha Miyagawa Kōzan ō no den* (Biography of Miyagawa Kōzan, founder of Makuzuyaki), ca. 1889. [Among the papers of Edward S. Morse, Peabody & Essex Museum, Salem, Mass.]

Mitsukoshi Gofukuten, Osaka. *Makuzu Kōzan sakuhinshū* (Collection of works by Makuzu Kōzan). Osaka: 1920.

Miyagawa Kōsai, ed. *Makuzu*. Tokyo: Mainichi Shimbunsha, 1988.

Morse, Edward S. *Catalogue of the Morse Collection of Japanese Pottery*. Cambridge: Riverside Press, 1901. Reprint. Rutland, Vt.: Charles E. Tuttle Co., 1979.

Nakamura Tanio. *Edo-Rimpa and artists surrounding Sakai Hōitsu*. Kyoto: Shikosha Publishing Co., Ltd., 1980.

Nezu Institute of Fine Arts, comp. *Nanban and Shimamono: Exported Southeast-asian Ceramics for Japan, 16th–17th century*. Tokyo: Nezu Institute of Fine Arts, 1993.

*Official Catalogue of the Japanese Section, and Descriptive Notes on the Industry and Agriculture of Japan*. Philadelphia: Japanese Commission, 1876.

Pollard, Clare. "Miyagawa Kōzan (1842–1916) and the Development of Makuzu Ware" (working title). Ph.D. dissertation, Oxford University, in progress.

Rein, J. J. *The Industries of Japan. Together with an Account of its Agriculture, Forestry, Arts, and Commerce.* London: Hodder and Stoughton, 1889.

Saga Kenritsu Kyūshū Tōji Bunkakan. *Kindai no Kyūshū Tōji-ten* (Exhibition of modern Kyūshū ceramics). Saga Prefecture: Saga Kenritsu Kyūshū Tōji Bunkakan, 1983.

Schaap, Robert, et. al. *Meiji, Japanese Art in Transition.* Leiden: Society for Japanese Arts and Crafts, 1987.

Scidmore, Elizabeth Ruhumah. "The Porcelain-Artists of Japan." *Harper's Weekly* 2144 (January 22, 1898):83–88.

Shugio, H. "Japanese Art and Artists of Today. —II. Ceramic Artists." *International Studio Magazine* 41 (1910): 286–93.

*The Japan Weekly Mail.* Yokohama: H. Collins, 1872–1915.

Thomson, D. Croal, ed. *The Paris Exhibition 1900.* London: The Art Journal Office, 1901.

Uyeno Naoteru, ed. *Arts and Crafts.* Japanese Culture in the Meiji Era, vol. 8. English adaptation by Richard Lane. Tokyo: Pan-Pacific Press, 1958.

Volpe, Tod M. *Treasures of the American Arts and Crafts Movement 1890–1920.* New York: Harry N. Abrams, Inc., 1988.

Wilson, Richard L. *The Art of Ogata Kenzan: Persona and Production in Japanese Ceramics.* Tokyo and New York: Weatherhill, 1991.

Wilson, Richard L. and Saeko Ogasawara. *Ogata Kenzan: Zensakuhin to sono keifu* (Ogata Kenzan: his life and complete work). 4 vols. Tokyo: Yuzankaku, 1992.

*World's Columbian Exposition Official Publications: Revised Catalogue, Department of Fine Arts with Index of Exhibitors.* Chicago: W. B. Conkey, 1893.

Yamashita Kwanjiuro. *The Illustrated Catalogue of Japanese Fine Art Exhibits in the Art Palace at the Louisiana Purchase Exposition, St. Louis, Mo., U.S.A.* Kobe: Kwansai Shashin Seihan Insatsu Goshi Kaisha, 1904.

*Yokohama shokaisha shoten no zu* (Pictures of Yokohama companies and trading establishments). Yokohama: ca. 1890. In *Yokohama dōhanga* (Yokohama copper etchings). Yokohama: 1982.

Yokota Yōichi and Hida Toyojiro, eds. *Yokohama Makuzuyaki: Miyagawa Kōzan ten zuroku* (Makuzu ware of Yokohama: Catalogue of the Miyagawa Kōzan exhibition). Tokyo: Yomiuri Shimbunsha, 1986.

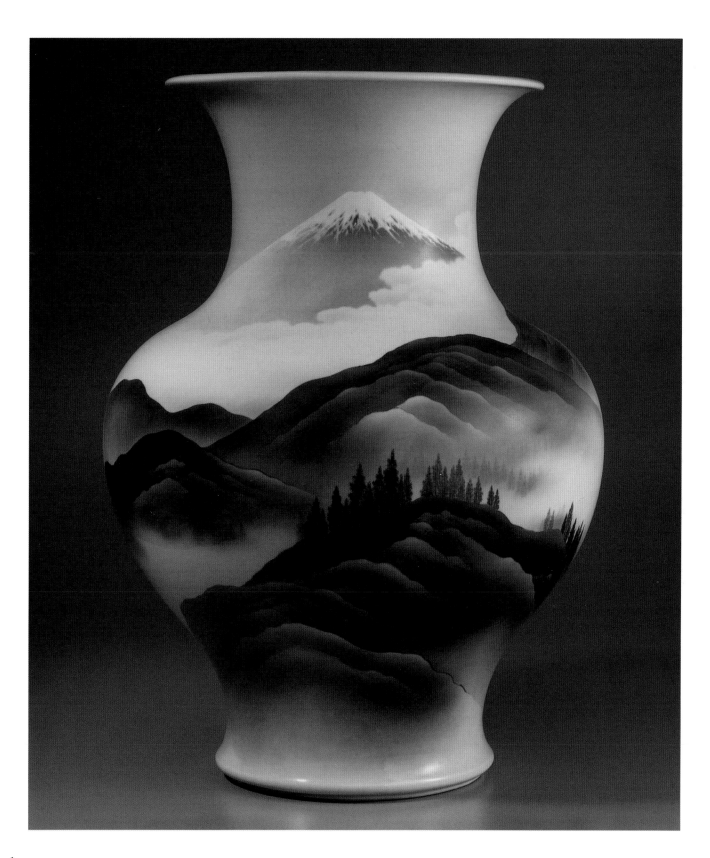

1

LARGE VASE WITH
MT. FUJI LANDSCAPE
*Porcelain with* moriage
*snow; underglaze cobalt*
*blue, white, pink*
*H. 62.5 x D. 48 cm*
*Mark:* Makuzu-gama
Kōzan sei *(Made by*
*Kōzan, Makuzu kiln)*

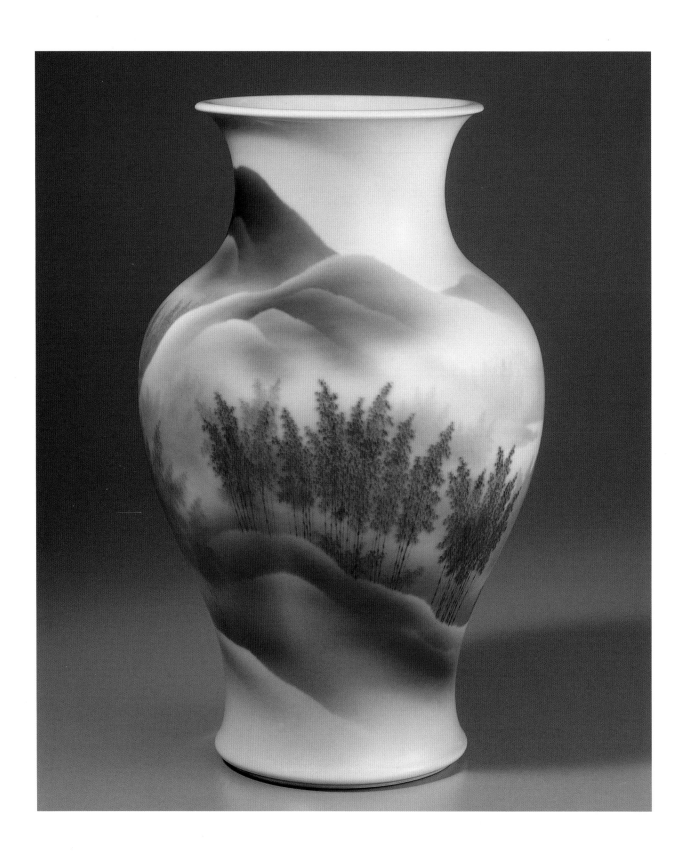

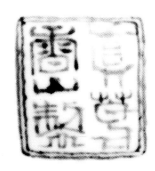

2
VASE WITH BAMBOO
GROVE LANDSCAPE
*Porcelain with underglaze*
*cobalt blue*
*H. 38.5 x D. 24.6 cm*
*Mark:* Makuzu Kōzan sei
*(Made by Makuzu Kōzan)*

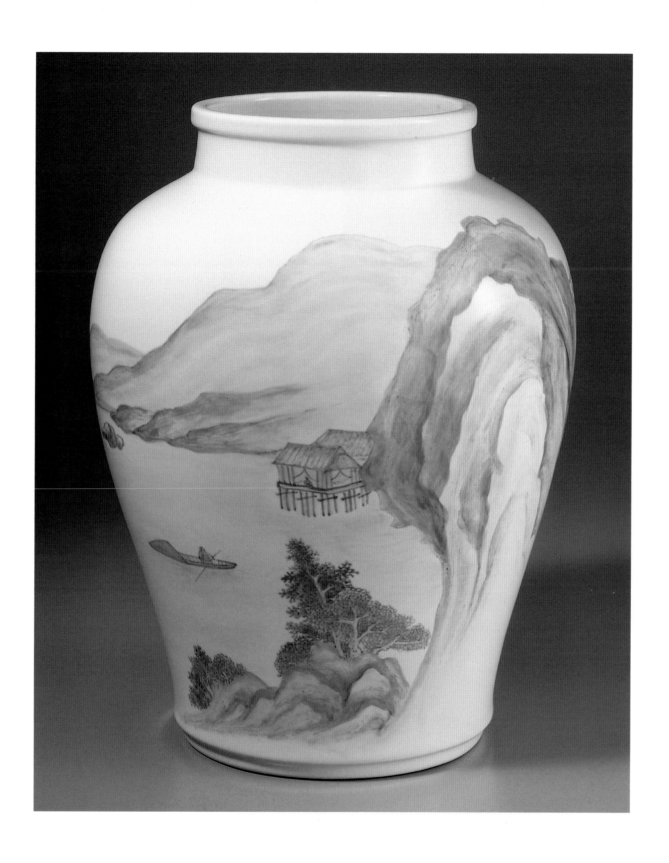

3
VASE WITH LANDSCAPE
*Porcelain with underglaze*
*cobalt blue*
*H. 39.8 x D. 31 cm*
*Mark:* Makuzu Kōzan sei

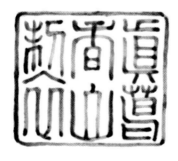

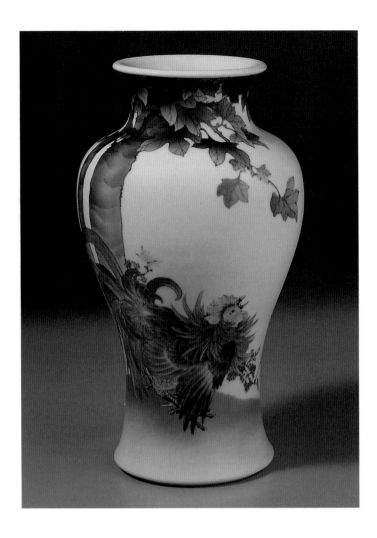

*4*

VASE WITH CROWING
ROOSTER UNDER
PAULOWNIA TREE
*Porcelain with* moriage
*rooster head; underglaze
cobalt blue,
black, red, yellow; over-
glaze red*
*H. 32.1 x D. 18.6 cm*
*Mark:* Makuzu Kōzan sei

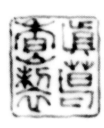

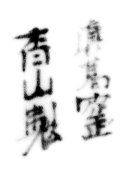

*5*

VASE WITH WHITE HUNT-
ING HAWK ON A STAND
*Porcelain with* moriage
*hawk and cord; underglaze
cobalt blue, pink, yellow,
green, brown, black*
*H. 40.2 x D. 24.5 cm*
*Mark:* Makuzu-gama Kōzan
sei

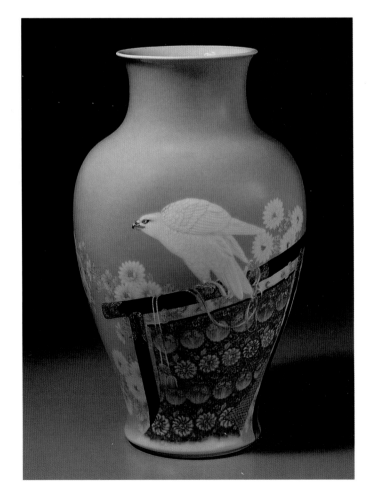

**6**

BAMBOO EWER WITH
SPARROWS

*Porcelain with attached
leaves, culms, snail;
underglaze cobalt blue,
pink*

*H. 19.6 x W. 16 x
D. 9.7 cm*

*Mark:* Kōzan sei *(Made
by Kōzan)*

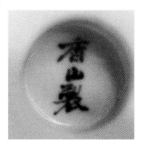

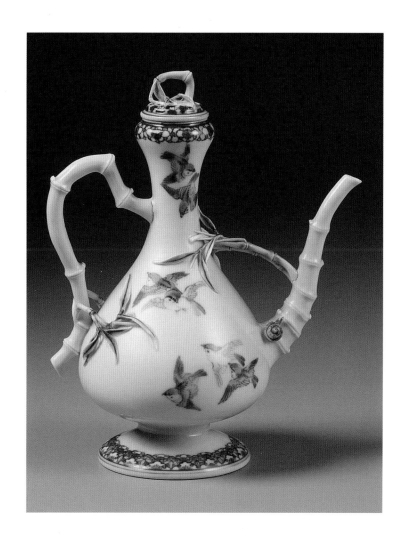

**7**

DOUBLE-HEADED
PHOENIX VESSEL

*Porcelain with underglaze
cobalt blue*

*H. 21.6 x W. 29.1 x
D. 21 cm*

*Mark:* Makuzu Kōzan sei

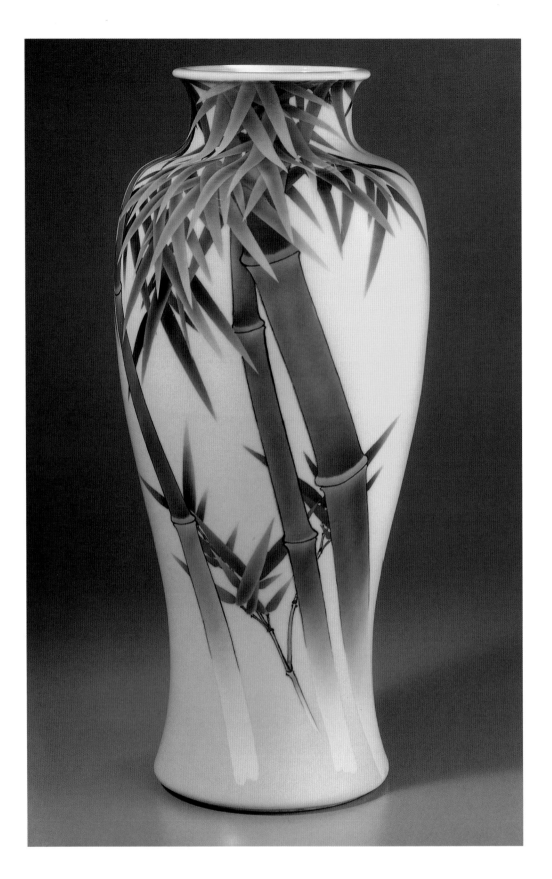

8
VASE WITH BAMBOO
*Porcelain with under-*
*glaze cobalt blue;*
*overglaze yellow*
*H. 58.5 x D. 26.7 cm*
*Mark:* Makuzu-gama
Kōzan sei

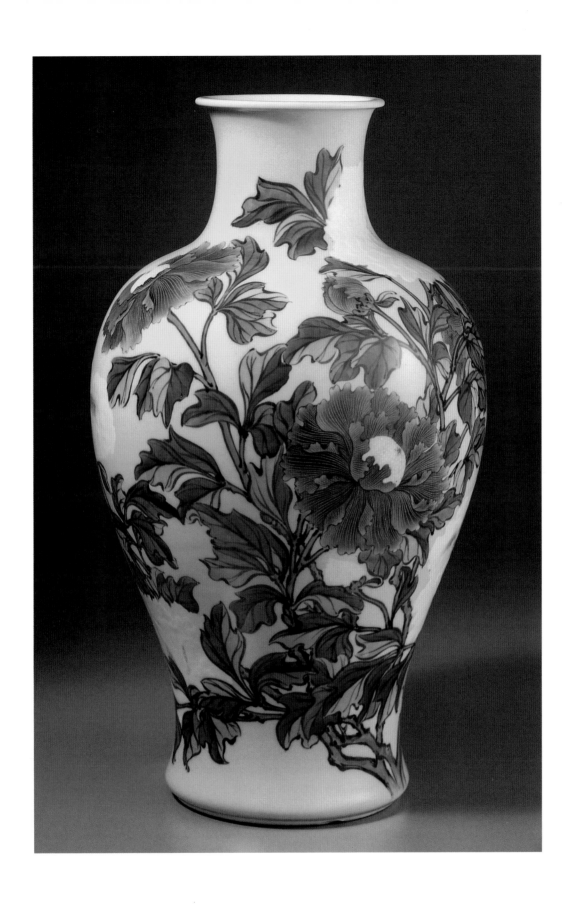

9

VASE WITH PEONIES

*Porcelain with* moriage
*white peonies; underglaze*
*cobalt blue, mauve,*
*green; overglaze yellow*
*H. 49.2 x D. 29 cm*
*Mark:* Makuzu-gama

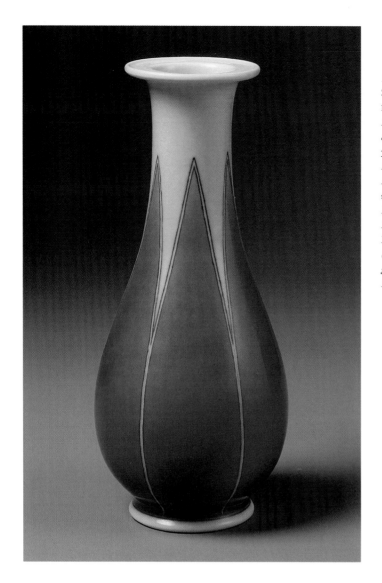

**10**
SMALL VASE WITH
FLOWER BUD DESIGN
*Porcelain with underglaze
cobalt blue; overglaze
yellow*
*H. 28.8 x D. 13 cm*
*Mark:* Makuzu Kōzan
saku *(Made by Makuzu
Kōzan)*
*Box:* Kabin / kiyū / seika /
Makuzu Kōzan saku
*(Vase / yellow
glaze / blue / made by
Makuzu Kōzan)*

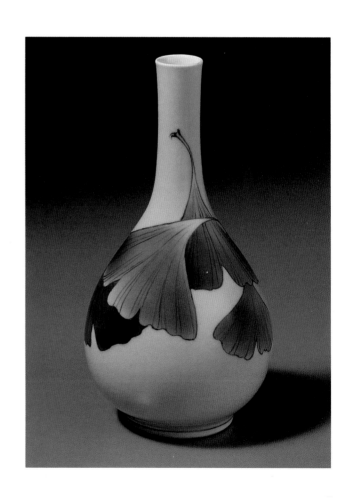

**11**
SMALL VASE WITH
FALLING GINGKO
LEAVES
*Porcelain with under-
glaze blue; overglaze
yellow*
*H. 21.9 x D. 11.8 cm*
*Mark:* Makuzu Kōzan
sei

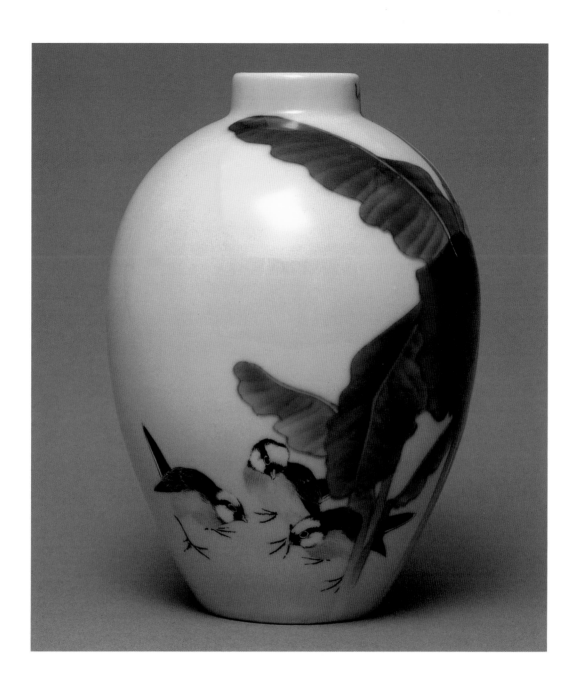

12

SMALL VASE WITH
SPARROWS UNDER
BANANA PLANT
*Porcelain with underglaze*
*cobalt blue, black, pink,*
*yellow; overglaze yellow*
*H. 18 x D. 13 cm*
*Mark:* Makuzu Kōzan sei
*Box:* Kabin / kiyū / seika /
bashō ni kotori e /
Makuzu Kōzan saku
*(Vase / yellow glaze / blue /*
*small birds under banana*
*plant painting / made by*
*Makuzu Kōzan)*

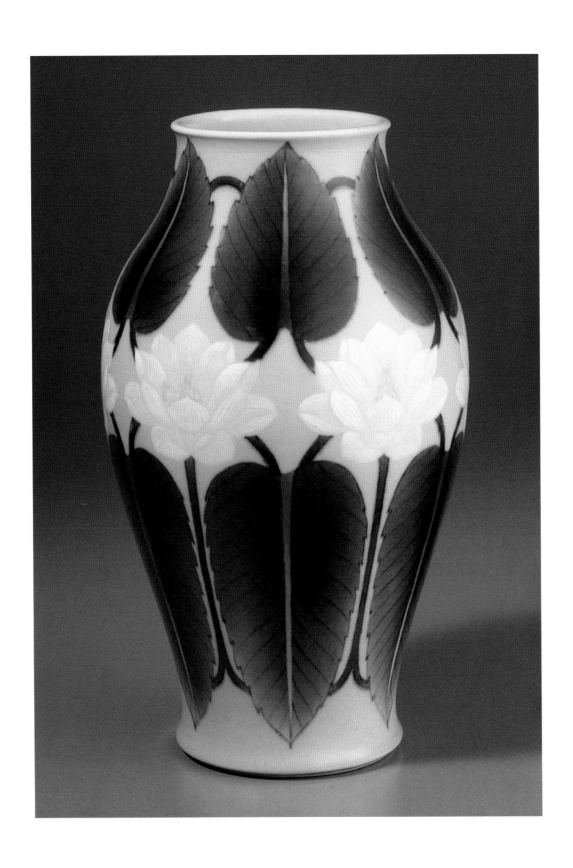

13
VASE WITH LOTUS AND
LEAF DESIGN
*Porcelain with* moriage
*lotus blossoms; underglaze*
*cobalt blue; overglaze*
*yellow*
*H. 32.5 x D. 19.5 cm*
*Mark:* Makuzu Kōzan sei

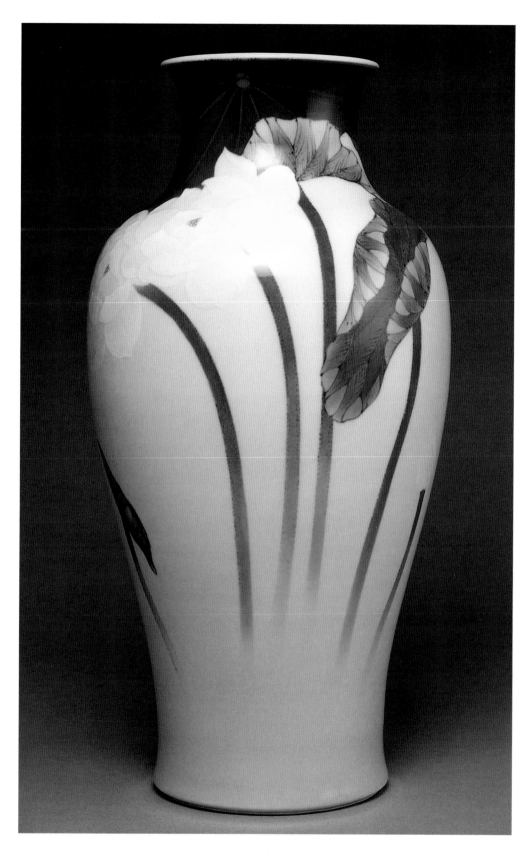

## 14

### VASE WITH BLOSSOMING LOTUS

*Porcelain with* moriage *lotus blossoms; under-glaze cobalt blue, green, red*

*H. 35.8 x D. 17.5 cm*

*Mark:* Makuzu Kōzan sei

*Box:* Makuzu-gama / hakuren e / kabin / Miyagawa Kōzan sei *(Makuzu kiln / white lotus painting / vase / made by Miyagawa Kōzan)*

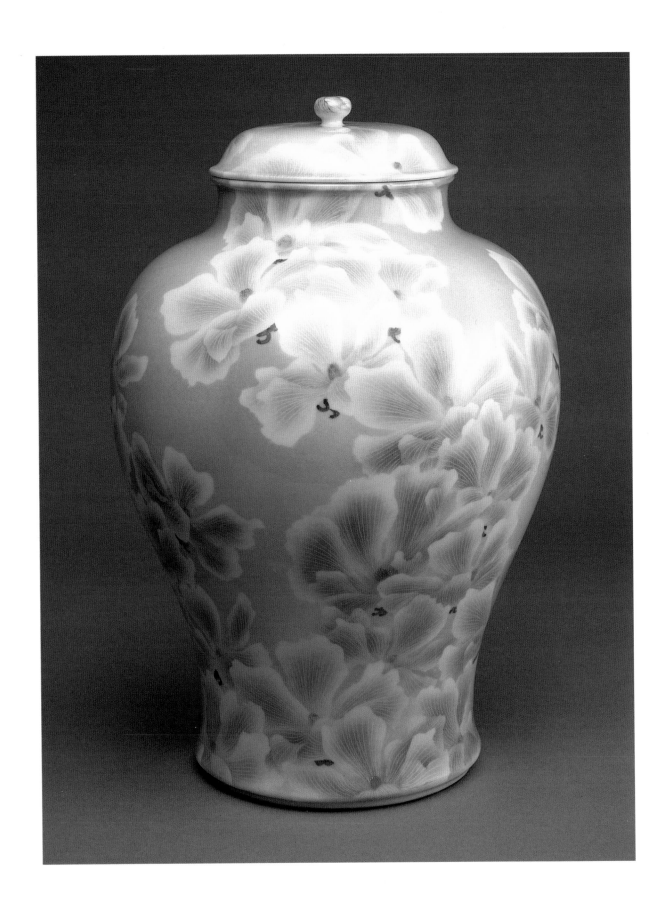

15

COVERED JAR WITH
MAGNOLIA
*Porcelain with under-*
*glaze green, pink, white*
*H. 33.5 x D. 23.5 cm*
*Mark:* Makuzu-gama
Kōzan sei

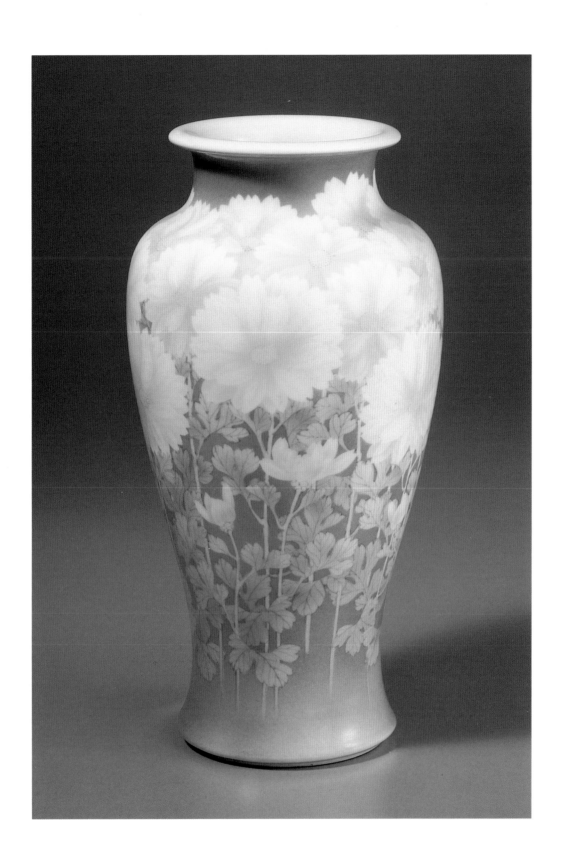

16
VASE WITH
CHRYSANTHEMUMS
*Porcelain with underglaze*
*green, yellow*
*H. 29.4 x D. 15.5 cm*
*Mark:* Makuzu Kōzan sei

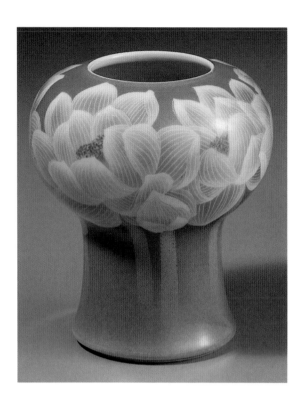

17

SMALL VASE WITH
LOTUS BLOSSOMS
*Porcelain with under-*
*glaze green*
*H. 12.3 x D. 11 cm*
*Mark:* Makuzu Kōzan
sei

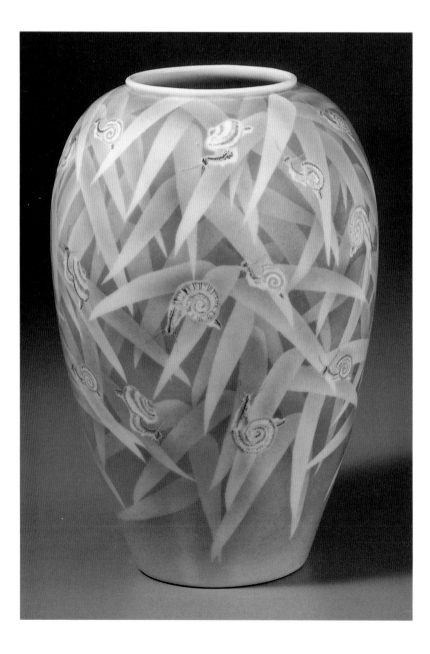

18

VASE WITH SNAILS ON
*SASA* LEAVES
*Porcelain with* moriage
*snails; underglaze green,*
*pink, brown*
*H. 24 x D. 16.5 cm*
*Mark:* Makuzu-gama
Kōzan sei

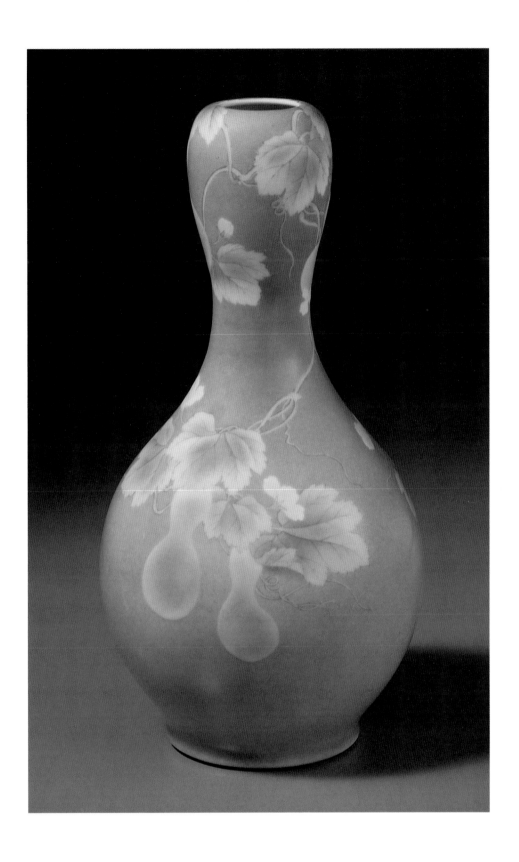

19

GOURD-SHAPED VASE
WITH GOURD VINE
*Porcelain with* moriage
*gourds, blossoms; under-*
*glaze green, yellow*
*H. 32 x D. 16.5 cm*
*Mark:* Makuzu-gama
Kōzan sei

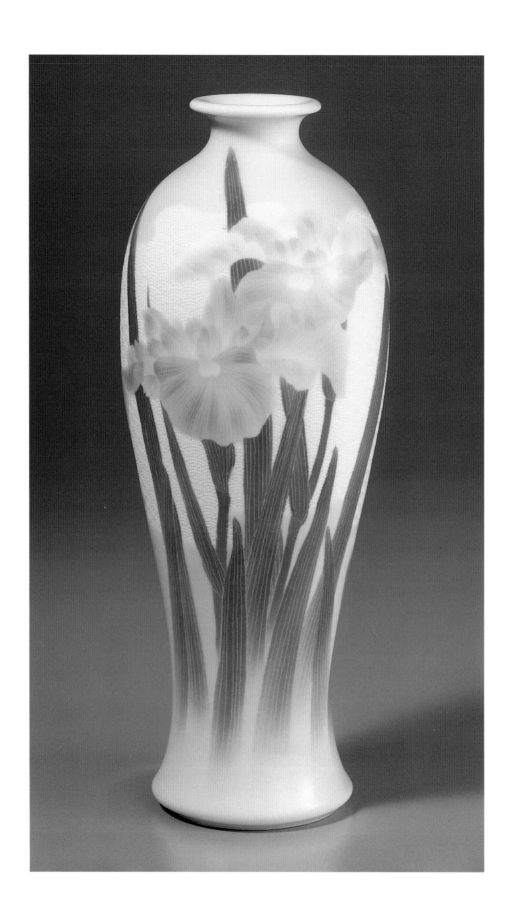

20

VASE WITH IRISES AND
INCISED WAVE PATTERN
*Porcelain with underglaze
green, purple, pink, blue
H. 33.5 x D. 13 cm
Mark: Makuzu Kōzan sei*

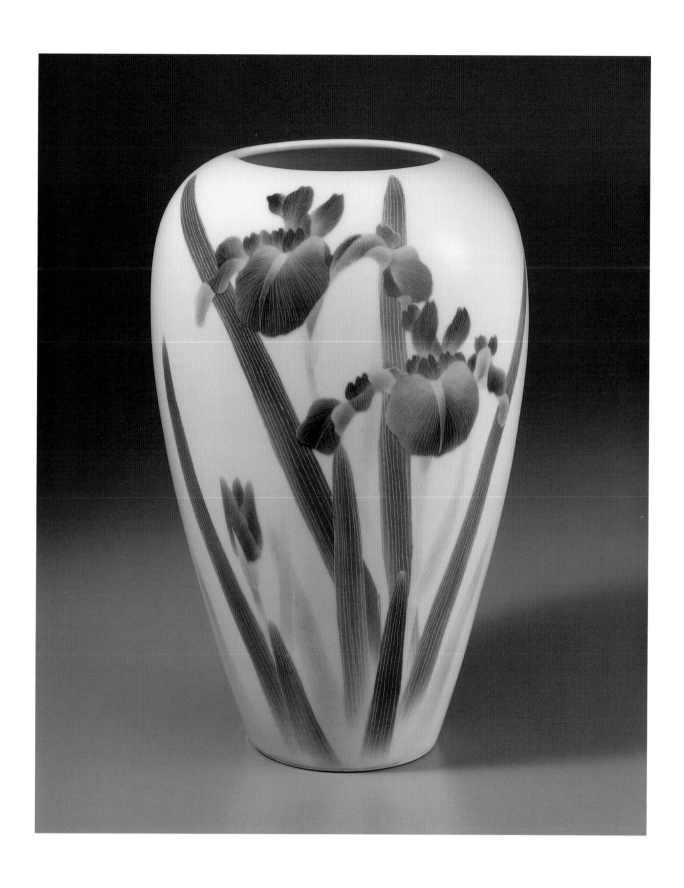

21

VASE WITH IRISES

*Porcelain with underglaze*

*green, purple*

*H. 32.1 x D. 21.5 cm*

*Mark:* Makuzu Kōzan sei

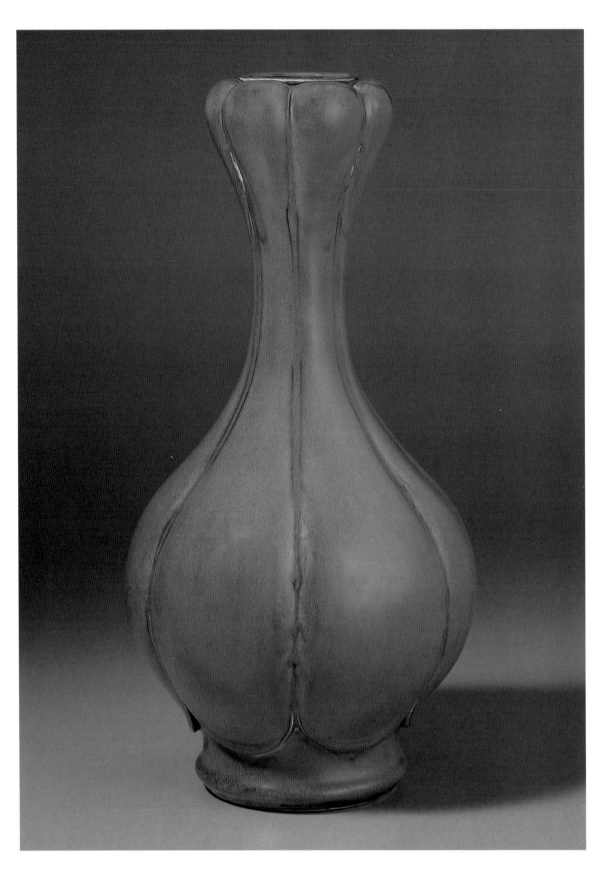

22
LOBED VASE
*Porcelain with green-*
*brown glaze*
*H. 47.5 x D. 23.7 cm*
*Mark:* Makuzu-gama
Kōzan sei

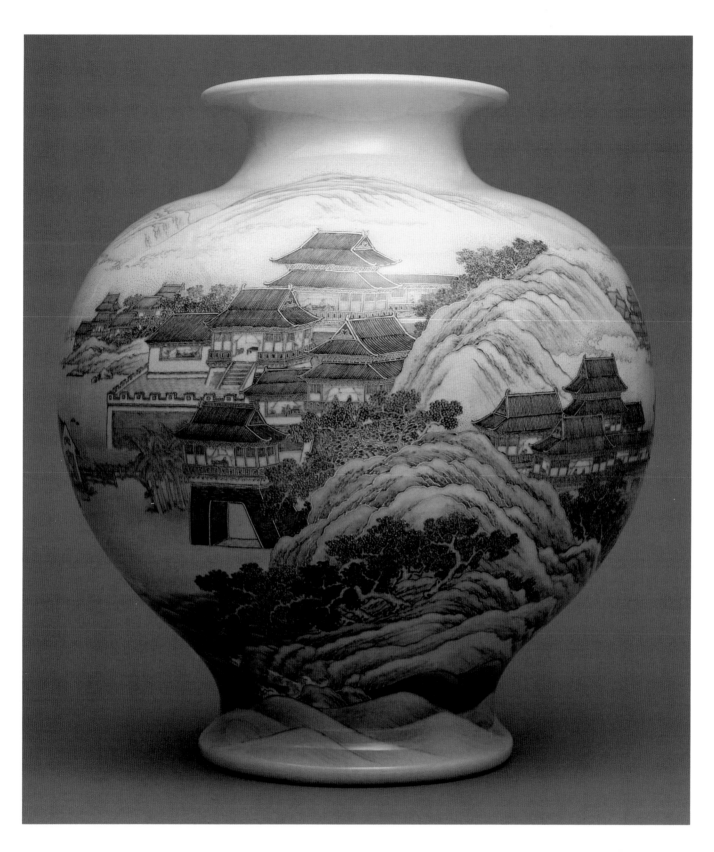

23
LARGE VASE WITH
CHINESE ARCHITECTURE
IN LANDSCAPE
*Stoneware with underglaze*
*cobalt blue; overglaze green,*
*red, yellow, gold*
*H. 45.7 x W. 40.5 cm*
*Mark:* Makuzu Kōzan sei

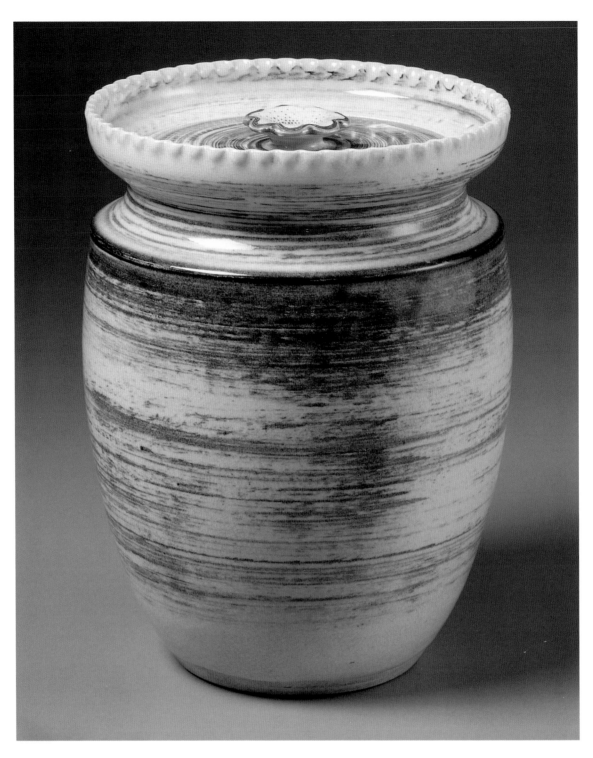

24
FRESH-WATER JAR IN
NINSEI STYLE
*Stoneware with underglaze*
*cobalt blue, iron; overglaze*
*green, red, gold*
*H. 22 x D. 17 cm*
*Mark:* Makuzu
*Box:* Mizusashi / Ninsei-i /
hakeme / Makuzu Kōzan
saku
*(Fresh-water jar / Ninsei-*
*inspired / hakeme / made*
*by Makuzu Kōzan)*

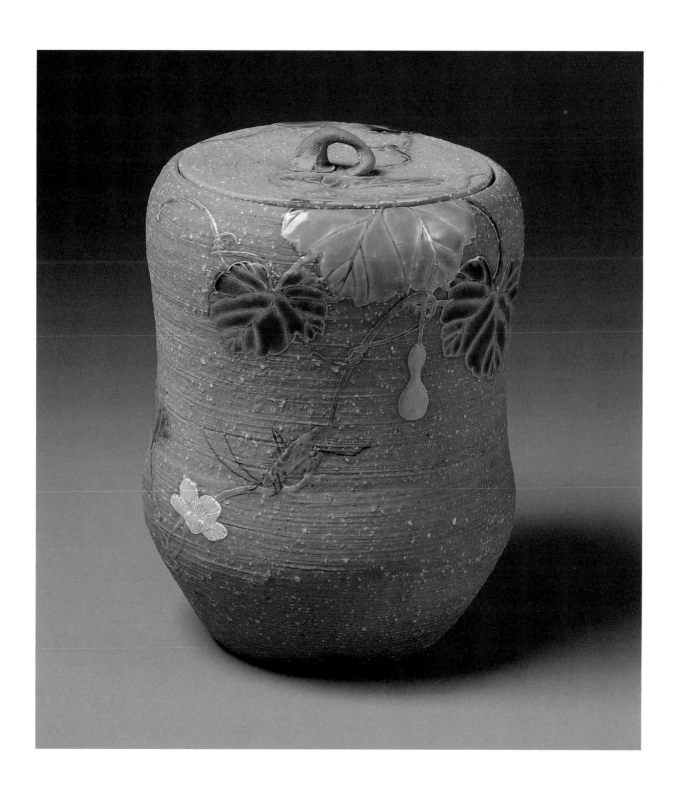

25

FRESH-WATER JAR WITH
GRASSHOPPER ON A
GOURD VINE
*Stoneware with ash glaze*
*inside; overglaze white,*
*black, green, turquoise,*
*teal, orange, yellow, gold*
*H. 18.2 x W. 13.6 cm*
*Mark:* Makuzu

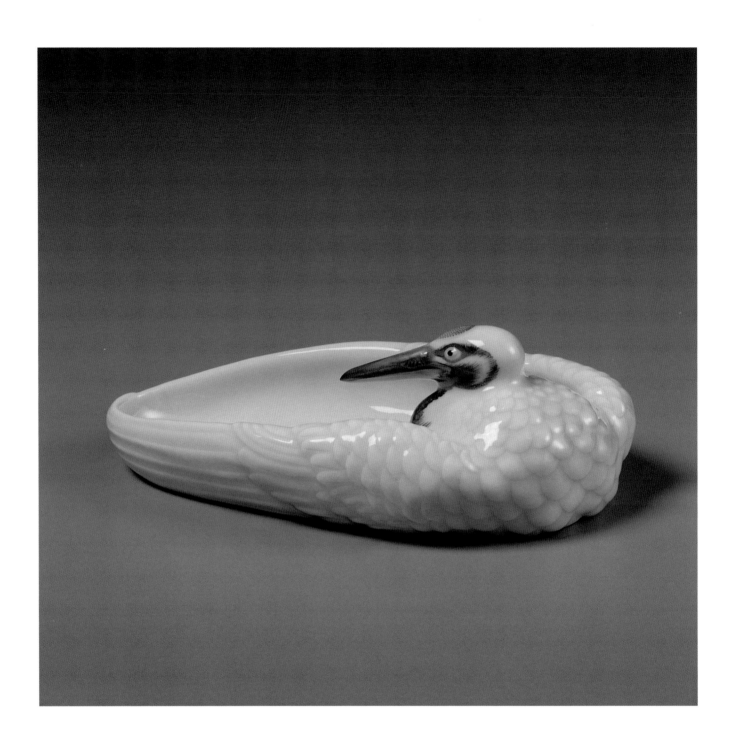

26
ASH CONTAINER IN
SHAPE OF CRANE
*Porcelain with underglaze
black; overglaze red*
*H. 5.7 x W. 16.8 x D. 9.2 cm*
*Mark:* Makuzu
*Box:* Haiki / tanchō tsuru /
Makuzu Kōzan saku *(Ash
container / red-headed crane /
made by Makuzu Kōzan)*

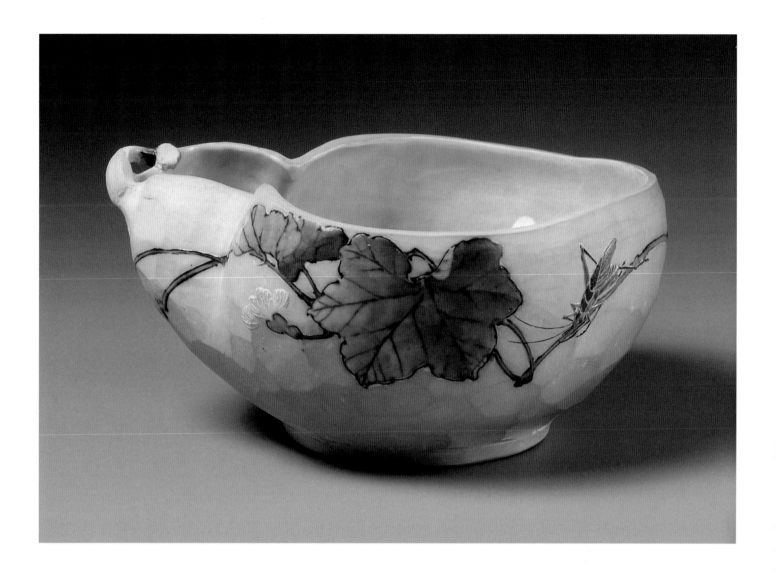

27

**GOURD-SHAPED DISH
WITH VINE**

*Stoneware with bluish celadon
glaze inside; underglaze cobalt
blue; overglaze white, green,
brown, black, yellow, gold
H. 9.2 x W. 18.5 x D. 17 cm
Mark: Makuzu
Box: Kashiki / hyōtan / mushi
no e / Makuzu Kōzan saku
(Cake dish / gourd / insect
painting / made by Makuzu
Kōzan)*

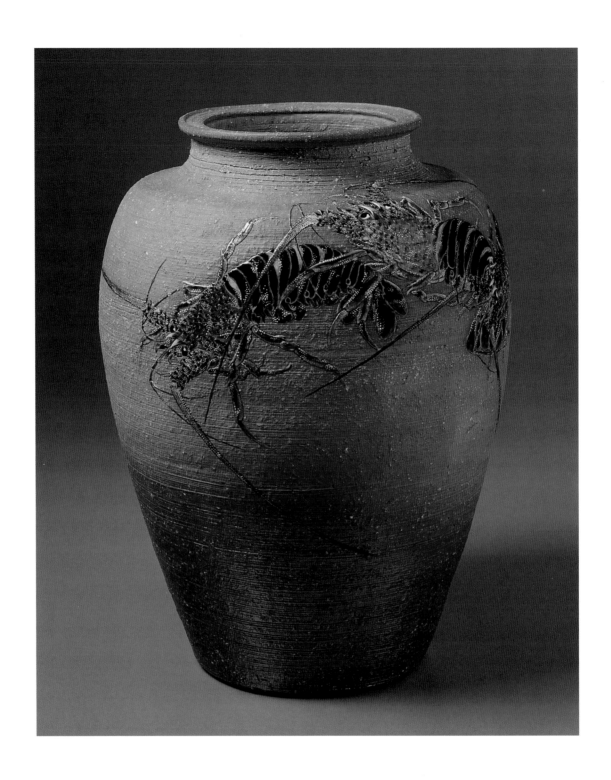

28

LARGE VASE WITH
SWIMMING PRAWNS
*Stoneware with iron oxide*
*wash; overglaze brown,*
*orange, white,*
*black, yellow*
*H. 35 x D. 27.2 cm*
*Mark:* Makuzu
*Box:* Kabin / masagohada /
ebi e / Makuzu Kōzan
saku  *(Vase / sandskin /*
*prawn painting / made by*
*Makuzu Kōzan)*

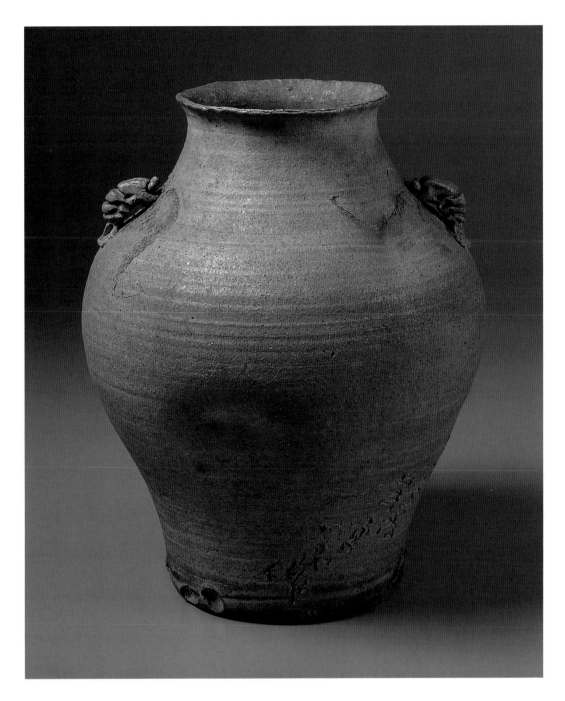

29

VASE IN *NAMBAN* STYLE
WITH PRAWN HANDLES
*Unglazed stoneware*
H. 32 x D. 27 cm
*Mark:* Makuzu
*Signed:* Nanajugo okina
Makuzu Kōzan saku
*(Made by old man Makuzu
Kōzan, seventy-five)*
*Box:* Kabin / namban han-
nera-i / nanajugo okina
Kōzan isaku / Makuzu
Kōzan *(Vase / inspired by
namban hannera / remain-
ing work of old man Kōzan,
seventy-five / Makuzu
Kōzan)*

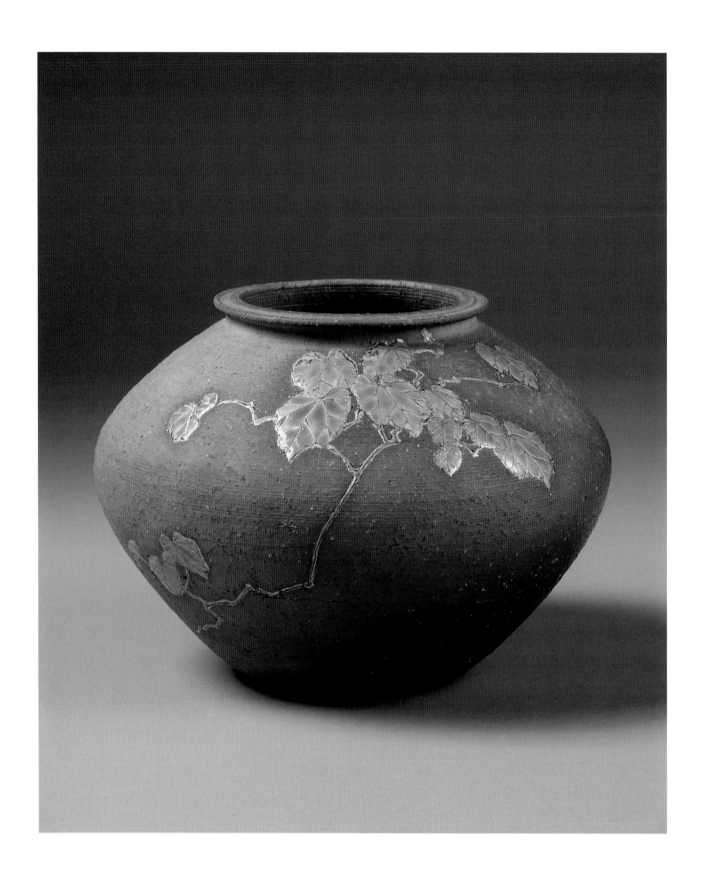

30

VASE WITH IVY VINE

*Stoneware with ash glaze
inside; iron oxide wash;
overglaze black, green,
gold*

*H. 15.8 x D. 21.5 cm*

*Marks:* Makuzu, Kōzan

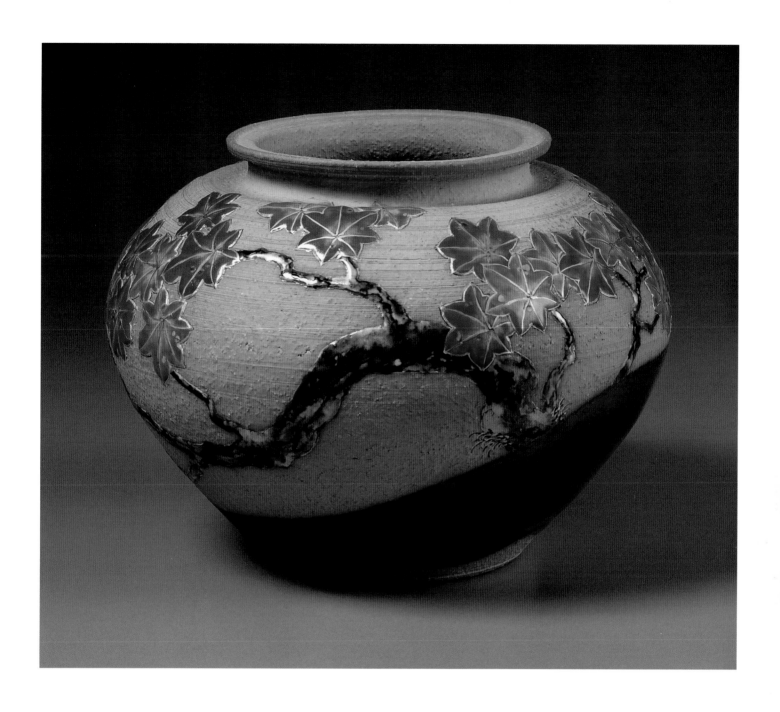

31

VASE WITH AUTUMN
MAPLE

*Stoneware with ash glaze*
*inside; black glaze; over-*
*glaze iron, red, green,*
*brown, gold*
*H. 17.1 x W. 24.7 cm*
*Mark:* Makuzu
*Box:* Kabin / masagohada /
iro-e kaede no e / Makuzu
Kōzan saku *(Vase / sandskin /*
*enameled maple tree painting /*
*made by Makuzu Kōzan)*

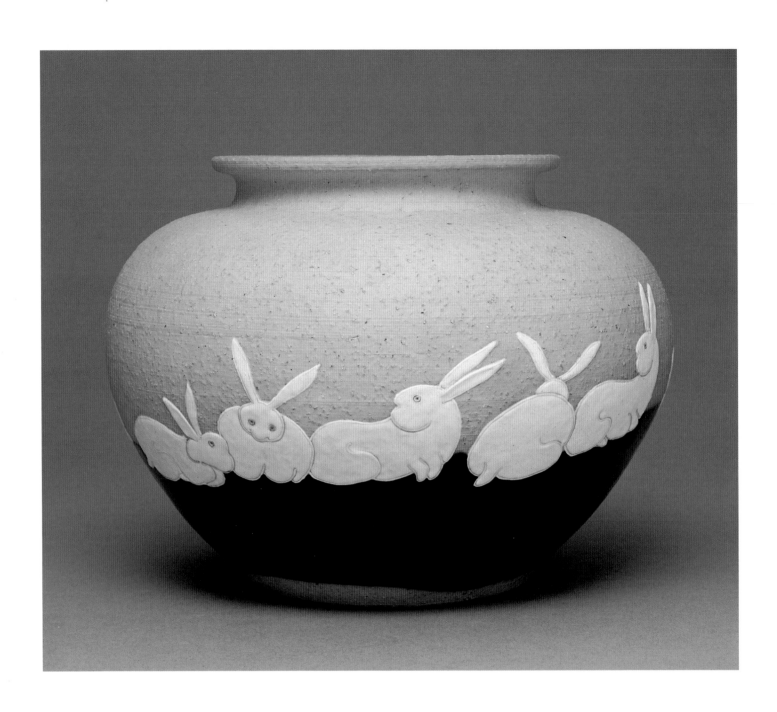

32
VASE WITH LINE OF
RABBITS
*Stoneware with ash glaze
inside; black glaze; white
glaze with overglaze
white, red*
*H. 17 x D. 23.1 cm*
*Mark:* Makuzu

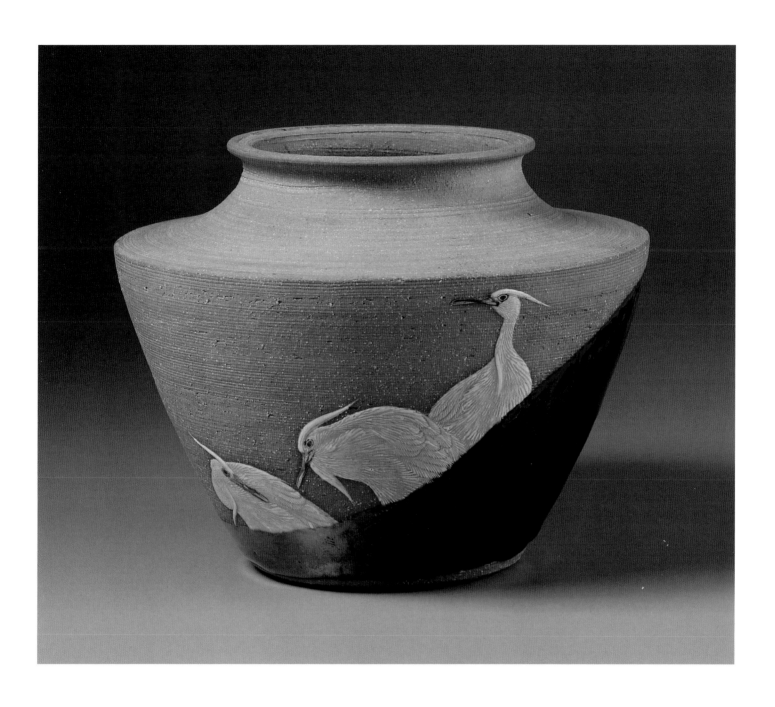

33

VASE WITH *KAKIWAKE*
DESIGN AND WHITE
HERONS

*Stoneware with* moriage
*herons; Seto iron glaze;*
*white glaze with overglaze*
*white, iron, gold*
*H. 14.8 x D. 20.0 cm*
*Mark:* Makuzu
*Box:* Kabin / ko-Seto yū /
murasagi e / Makuzu Kōzan
saku *(Vase / old Seto glaze /*
*group of herons / made by*
*Makuzu Kōzan)*

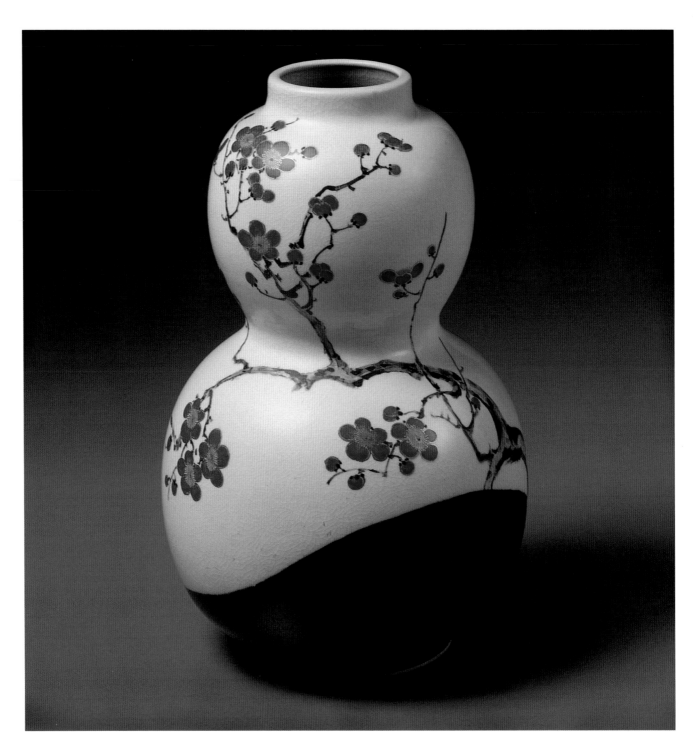

34

GOURD-SHAPED VASE
WITH *KAKIWAKE* DESIGN
AND PRUNUS
*Stoneware with black*
*glaze, underglaze iron;*
*overglaze red, green, gold,*
*brown*
*H. 26.5 x D. 17.2 cm*
*Mark:* Makuzu
*Box:* Kabin / iro-e hyōtan /
ume no e / Makuzu Kōzan
saku *(Vase / enameled*
*gourd / prunus painting /*
*made by Makuzu Kōzan)*

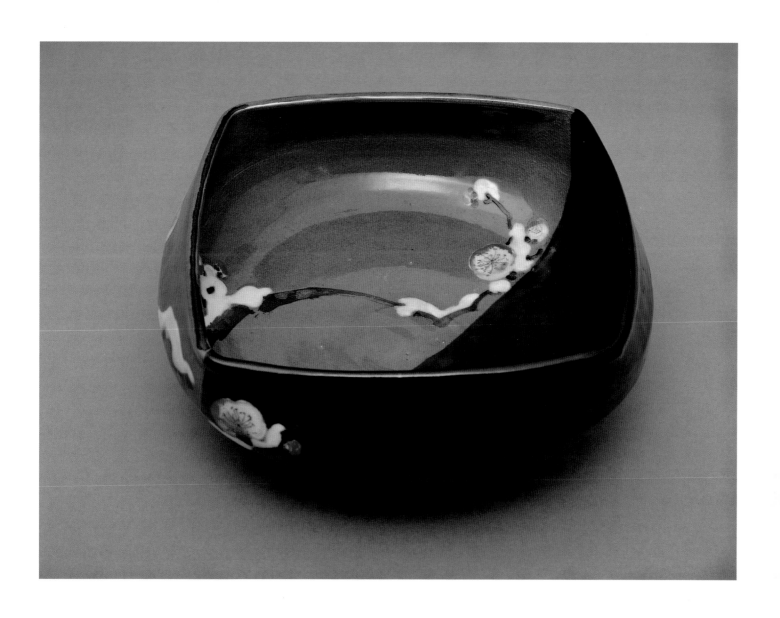

*35*

CAKE DISH WITH *KAKI-WAKE* DESIGN AND SNOWY PRUNUS BRANCH
*Stoneware with black glaze; underglaze iron, white, yellow; overglaze red, green, gold*
*H. 8.1 x W. 21.0 cm*
*Marks:* Makuzu, Kōzan
*Box:* Kashiki / ōkonomu / chōseisetsu / Makuzu Kōzan saku *(Cake dish / by special request / clear morning snow / made by Makuzu Kōzan)*

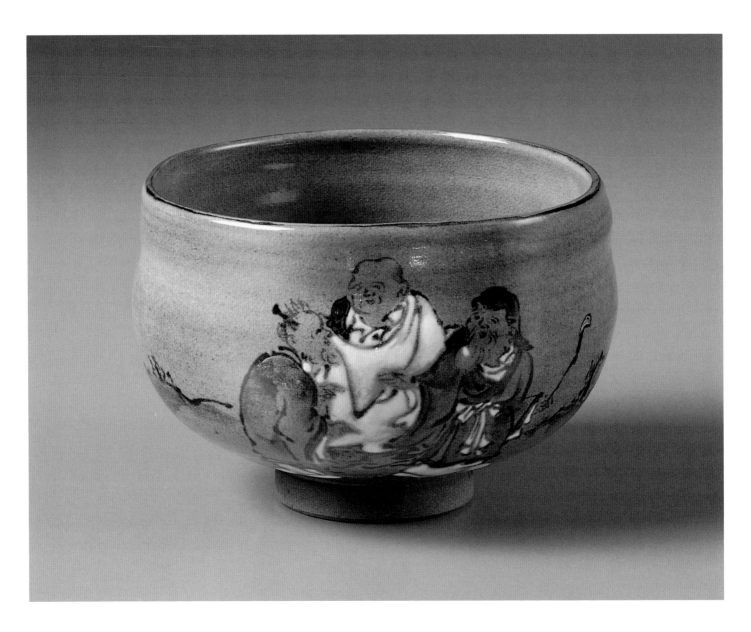

36

KENZAN-STYLE TEABOWL
WITH THE "THREE
LAUGHERS"
*Stoneware with underglaze
iron, white slip; overglaze
green, gold*
*H. 8.5 x D. 12.7 cm*
*Marks:* Makuzu, Kōzan
*Box:* Chawan / Kenzan-i /
sanshō e / nanajugo okina
Kōzan isaku / nidai
Makuzu Kōzan *(Teabowl /
Kenzan-style / Three
Laughers painting /
remaining work of old man
Kōzan, seventy-five [1916] /
2nd-generation Makuzu
Kōzan)*

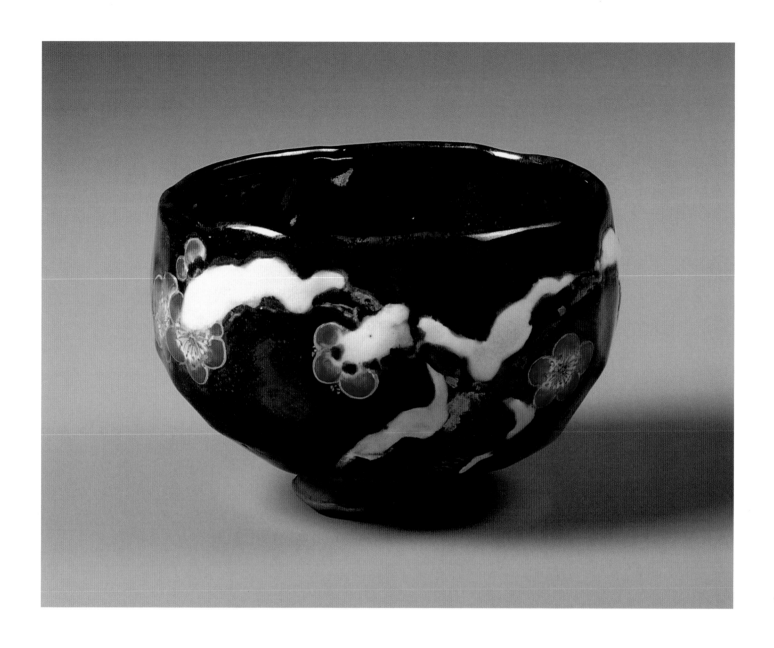

**37**

TEABOWL WITH SNOW
ON A BLOSSOMING
PRUNUS

*Stoneware with iron*
*oxide glaze; underglaze*
*white, yellow, black;*
*overglaze red, green, gold*
*H. 8.5 x D. 12.4 cm*
*Marks:* Makuzu, Kōzan
*Box: (lid)* Kōzan tsukuru /
Kenzan utsushi /
setchubai chawan /
Konnichi (kaō) *(Made by*
*Kōzan / Kenzan copy /*

*teabowl with plum*
*blossom in snow / [signed]*
*Konnichi [mark of tea-*
*master Tantansai*
*Sōshitsu])*
*Box: (bottom)* Kenzan-i /
kuroyū ume e / Makuzu
Kōzan saku *(Kenzan*
*inspired / black-glazed*
*prunus painting / made by*
*Makuzu Kōzan)*

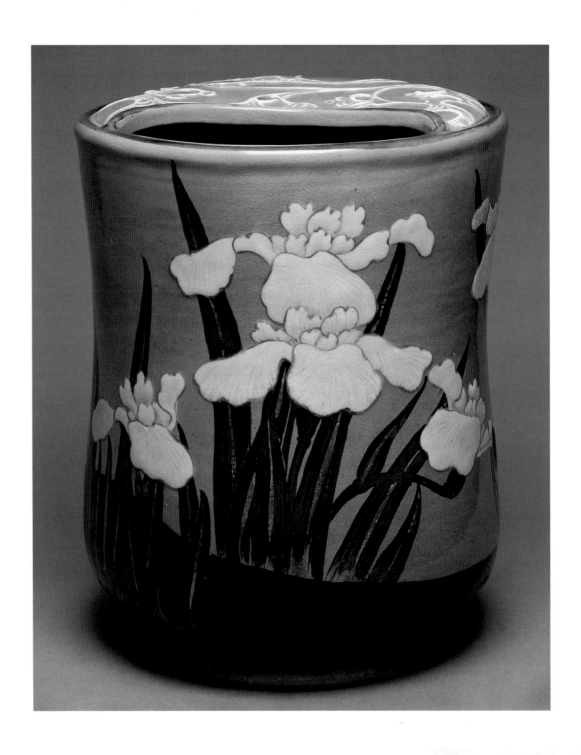

38
HANDWARMER WITH
*KAKIWAKE* DESIGN AND
IRISES
*Stoneware with* moriage
*irises, underglaze iron,*
*white slip; overglaze iron,*
*gold, silver*
*H. 26.4 x D. 22.2 cm*
*Marks:* Makuzu, Kōzan
*Box:* Te-aburi / Kenzan-i /
shōbu e / Makuzu Kōzan
saku *(Handwarmer /*
*Kenzan-style / iris painting /*
*made by Makuzu Kōzan)*

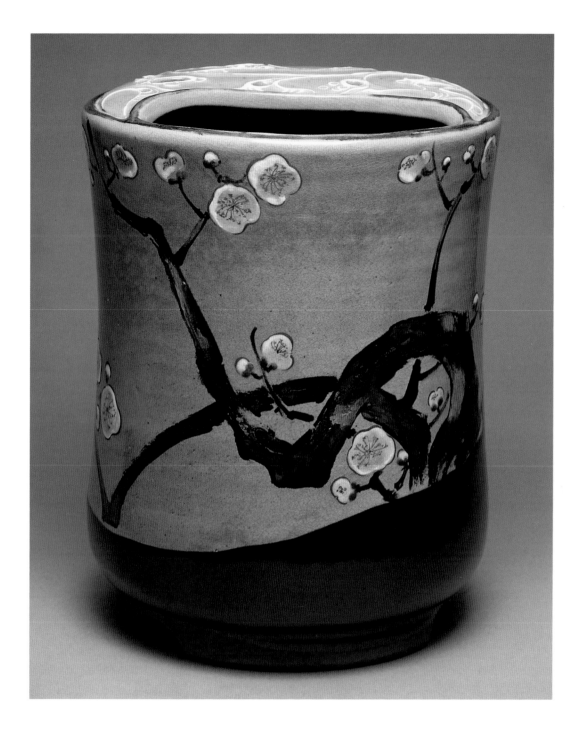

39
HANDWARMER WITH
KAKIWAKE DESIGN AND
PRUNUS
*Stoneware with underglaze
iron, yellow, white slip;
overglaze iron, green, gold,
silver*
*H. 26.7 x D. 22.5 cm*
*Marks:* Makuzu, Kōzan
*Box:* Te-aburi / Kenzan-i /
ume no e / Makuzu Kōzan
saku *(Handwarmer /
Kenzan-style / prunus paint-
ing / made by Makuzu
Kōzan)*

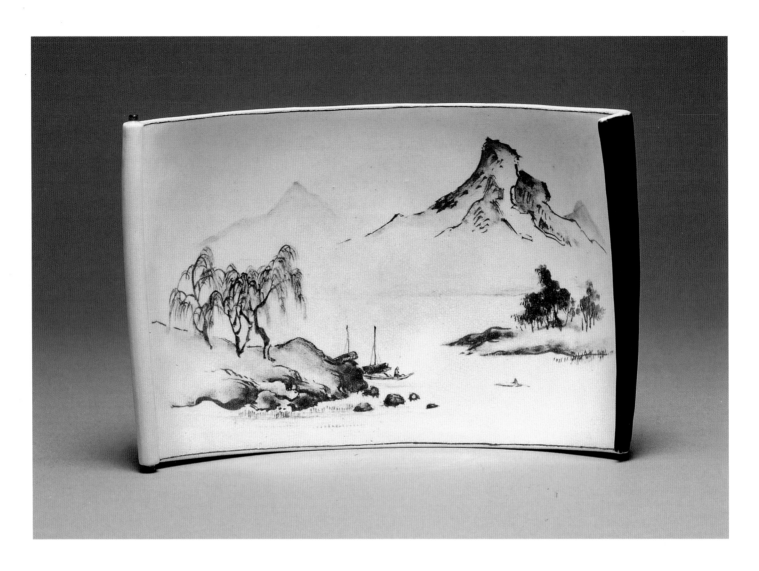

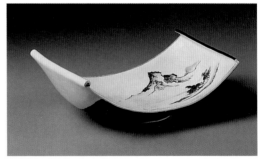

40

HANDSCROLL-SHAPED
DISH WITH LANDSCAPE
PAINTING
*Stoneware with black glaze;*
*underglaze iron, cobalt blue*
*H. 13.2 x W. 20.7 x*
*D. 6.5 cm*
*Mark:* Makuzu
*Box:* Kashiki / Makuzu-
gama / sansui no e / Kōzan
saku *( Cake dish / Makuzu*
*kiln / landscape painting /*
*made by Kōzan)*